DISCOVERING THE
RIVER TAMAR

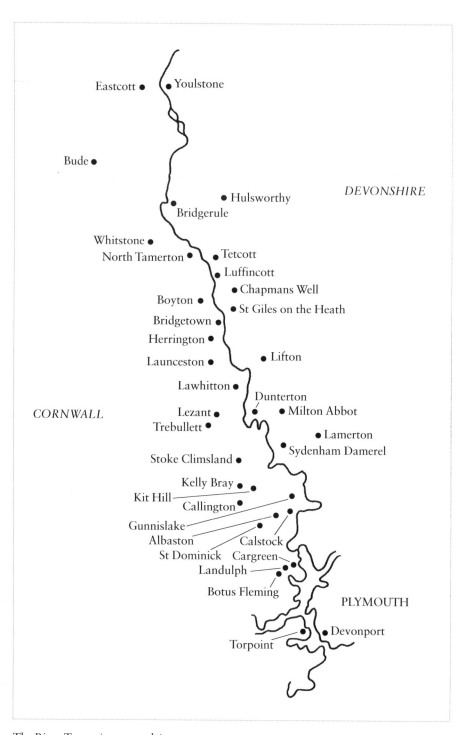

The River Tamar (not to scale).

DISCOVERING THE RIVER TAMAR

John Neale

AMBERLEY

For Gerald and Audrey Fry — two dear friends of long standing — and for all my friends who happen to live beside the Tamar and love it as much as I do!

First published 2010

Amberley Publishing Plc
Cirencester Road, Chalford,
Stroud, Gloucestershire, GL6 8PE

www.amberley-books.com

British Library Cataloguing in Publication Data.
A catalogue record for this book is available from the British Library.

ISBN 978 1 84868 866 7

Typesetting and Origination by Amberley Publishing.
Printed in Great Britain.

CONTENTS

INTRODUCTION

There is something magnetic about a river, which draws us to it and makes us admire it. Maybe it is in the name or perhaps its position in the landscape. We all have a favourite river, but to go in search of the source of the Tamar and follow it from its small beginnings through its changing borderland to the sea can be a journey of exploration.

Rising in the parish of Morwenstow in the remotest corner of north Cornwall, only a short distance from the coast, nearly making Cornwall an island, the Tamar embarks on journey of fifty or so miles to Plymouth.

For the most part, the river Tamar is passionately loved by those who live along its course, and it is from these people that the river enjoys an allegiance, all of whom will vehemently claim to live on the 'proper side' be it Devon or Cornwall.

The Tamar is so important that it is entrusted with a singular duty, which no other river in the entire country undertakes, as, for most of its course, it separates Devon from Cornwall and, apart from a few kinks, it effectively marks the jealously guarded borderland between the two counties.

There are many things to look for along the Tamar: churches, chapels, great houses, inns, mills, picturesque villages, canals, mines and bridges as it wends its way through a landscape peppered with myth, murder, legend and mystery.

Along its course the river is swollen by several tributaries and numberless small streams, which in total drain hundreds of square miles of land.

There are historic bridges, some standing entirely in Devon, others wholly in Cornwall, while others stand defiant with one foot firmly planted in each county.

The river Tamar wends its way from its humble beginning amid the windswept waste land of north Cornwall past farmland, on towards steep

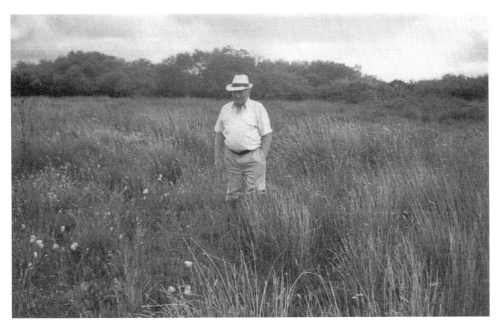

Ron Hicks near the centre of the boggy morass where the Tamar is born.

wooded valleys and to a wide sinuous estuary, where it is able to accommodate the biggest naval warships afloat.

The name Tamar is said by some eminent scholars to mean 'great water' and there is a legend about how it came into being. By all accounts, a nymph called Tamara had a great desire to wander freely in the mortal world. Tamara's parents warned her about the foolhardiness of the venture, but she chose to ignore them. Once during a foray into the earthly realm she encountered two giants from Dartmoor, Tawrage, or Torridge, and Tavy who vied for her favours. Tamara led the pair a merry dance until, on the point of exhaustion, they caught up with her. In the nick of time, her father, angered at her disobedience, intervened to save her. Fortunately he possessed magical powers and he cast a spell on both Tawrage and Tavy who both fell into a deep sleep. Tamara's father then begged his daughter to return with him but she, being wilful, flatly refused and he turned her into the river Tamar. He also turned Tamara's would-be suitors into two lesser rivers, the Torridge and the Tavy.

When Torridge awoke he was somewhat distressed and he began to look for Tamara, wandering aimlessly through the Devonshire countryside to no avail. Eventually realising that he was destined never to set eyes on Tamara again, he gave up his quest and turned in a great loop towards Bideford and

the Bristol Channel. When Tavy awoke he was distraught to find that Tamara had vanished and he too set off in search of her. For some unknown reason he began searching in the opposite direction and eventually fortune favoured him and he caught up with Tamara just before she met the open sea.

Legend it may be but one thing is certain, both the Torridge and Tamar rise near one another on Woolley Barrows, the one flowing toward Bideford and the other toward Plymouth.

Ptolemy, writing in the early centuries after the birth of Christ, tells us that in the country occupied by the Dumnonian people there are three main rivers, the Iska (Exe) the Tamara and the Kenion, believed to be the Fal.

At one time borderland skirmishes and incursions were commonplace. In AD 823, the Cornish, aided by the Danes, were heavily defeated by their troublesome neighbours, the Saxon Devonians at Galfulford on the river Lyd. Later, the marauding Saxons crossed the Tamar and settled in the Attery (Ottery) valley. Place names in the Attery valley prove this. On the one side they are Celtic and, on the northern bank, Anglo-Saxon in origin.

By AD 936, King Athelstan had firmly established the Tamar as the border between the Celtic Cornish and the Saxon English.

During the tenth century, the Attery valley settlements were ceded to Devon. Later, they fell under the jurisdiction of the Abbot of Tavistock, who made certain that these fertile acres and the revenue that came with them remained in Devon.

Anomalies connected with the county boundary line have always existed, some of which have been ironed out over time.

History, however, has a strange way of repeating itself. The mid-nineteenth century brought about further changes. One change has a fascinating story attached to it. The story has it that when the boundary commissioners were redrawing the county margins they eventually reached Werrington Park, near Launceston, where they lodged overnight, and wined and dined too freely. The following morning they set off and began tracing their line up the river Attery (Ottery) instead of the River Tamar, resulting in a somewhat irritating finger of Devon land poking into Cornwall.

However, it must be said here that there are a few anomalies remaining. Parts of the parishes of Whitstone and North Tamerton, where for a short distance the boundary deviates away from the river Tamar and the river Deer takes charge of the county margins is one such instance. Another borderline oddity is particularly noticeable on the road from Launceston to Bude. At Bevill's Hill the traveller leaves Cornwall and enters Devon and after a mile or so, at Jewell's Cross, he again enters Cornwall.

Later, as the river Tamar winds on and passes great houses and estates, through villages and countless farms, it is closely followed by the line of the Bude canal to Druxton Wharf, the terminus of the Launceston branch of the canal. After Druxton Bridge the Tamar flows to Netherbridge, Higher New Bridge, Polson Bridge, all of which have their tales to tell.

Around majestic Greystone Bridge the river carves its way through a steep-sided heavily-wooded valley of outstanding natural beauty before flowing through Endsleigh estate, beloved by the Dukes of Bedford, and then careers rapidly on to Horsebridge, some miles further downstream. Kit Hill, famous for its nineteenth-century quarrying and mining enterprises, dominates the landscape near Callington. From the summit, topped by its distinctive stack, and a landmark for miles around, there is a unique vantage point from which panoramic views unfold in every direction. Below Kit Hill the river Tamar's great meanders take it toward Latchley, Luckett, Harrowbarrow and Chilsworthy and the valley widens.

At Newbridge, Gunnislake, the Tamar becomes tidal. Once this was the last place where it could be crossed before Plymouth, some nineteen miles further downstream. Weir Head is the turning place for pleasure craft up from Plymouth. For a short distance, the old Tamar Manure Navigation Canal, which enables river craft to bypass the weir, marches alongside the river.

During the nineteenth century, the river Tamar was a great artery. Packhorse tracks, canals, roads and railways all made their way to the river ports from where vast quantities of minerals and goods were transported to all corners of this country and exported all over the world.

The river's rich industrial past becomes much more evident now. At one time, quarrying, brick making, boat building and mining all depended to a great extent on the river. In their heyday these enterprises employed thousands of local people.

Further downstream the patchwork quilt patterns of the market gardens, flower and vegetable farms and the few remaining flower farms, cherry and apple orchards appear, then lime kilns, ruinous mine buildings and chimney stacks punctuate the landscape.

At Morwellham Quay the Tavistock Canal makes its appearance and at Calstock the river widens and further downstream embraces the river Tavy. Together they sweep on to Saltash and under the Tamar Road Bridge and Brunel's Royal Albert Bridge.

Soon the river Lynher swells the stream and the trio slide below Torpoint and Devonport, to be joined by the river Plym. From here the four entwine and

flow on to meet the clashing waters of the Hamoaze and Plymouth Sound and are quickly engulfed by the open sea.

The ever-changing river Tamar from its source to the sea is without doubt one of the most fascinating watercourses in the West Country.

The river Tamar will always rise in Morwenstow parish, from where it will rally its strength, and discover its taste for adventure. Later, it will gain in status and raise its profile from an insignificant trickle of water seeping shyly from a bog, into a great West Country river making a natural barrier, dividing, for most of its length, Cornwall from Devon and the rest of England.

ACKNOWLEDGEMENTS

I would like to express my sincere thanks to the following people, each of whom gave freely of their time and knowledge in answering questions about the river Tamar and for providing hitherto unpublished photographs.

Canon Geoffrey Pengelly, Clare Stanbury, Gerald and Audrey Fry, Ray and Vera Shaddick, Julie Gale, Neil and Ruth Burden (Trecarrell Manor research), Peter and Fay du Plessis, Arthur Wills, Ruby Edgcumbe, Ernie Hicks, Bill and Margaret Dinner, Rhona Cowling, Francis and Anne Hine, Michael Sanders, Barbara and Keith Shaw, Sue Wood, Charlie Walters, Derek Hambly, Trevor Sillifant, Steven Gibson, Jim Edwards, Peter Clarke, Henry Westlake, Bill and Jean Cole, Arthur and Joan Uglow, and Miss Samantha Coryton

Michael and Brenda Hatch, Shane Terry and the Milton Abbot Players, Mr Mykytyn of Bodmin, Derek and Mary Scofield, David and Sue Watts, Charlie and Gloria Cottle, Colin Barrett, George Babb, Tony Lucas, Jill Mingo, Robert Wiggins, Frith, Valentine, Argyll and other unidentified picture postcard publishers.

The staff of the Launceston branch of Cornwall County Libraries, Lynda Harman and Calstock Parish Archive Trust, the staff of the Holsworthy and Tavistock branches of Devon County Libraries, Kim Cooper and the staff of the Cornwall Centre in Redruth, Angela Broome of Courtney Library, Royal Institution of Cornwall, Truro, the staff of Bricknell's Stationers in Launceston.

Last but certainly not least, the staff of Clemens Photography of Bodmin who, as always, worked miracles and more with old photographs.

My deepest apologies to anyone who has been inadvertently overlooked. Thank you all.

I

IN THE BEGINNING

In the country's overall river scene the Tamar is not a big player but it is arguably the most important river in the West Country.

For those who explore along its course from its humble beginnings to its grand finale at Plymouth the pleasure is enormous.

The exact source of the river is difficult to pinpoint as it comes secretly out from a boggy morass, but a narrow side road leading to Newlands and East Youlstone Farms, off the Bude to Bideford highway, takes the explorer to the river's birthplace.

Behind a hedge near some willow trees at Woolley Barrows is the bog which gives birth to the river Tamar.

Nearby a slate parish boundary marker proves that the bog, the source of the river, is in Morwenstow parish but within the proverbial stone's throw of being in the neighbouring parish of Bradworthy.

A small square stone culvert drains the first tentative trickle of water away from the bog, through a hedge and into a ditch. From here a pipe carries the water under the highway and the infant river Tamar is on its way to the sea at Plymouth.

It is a strange sight to see a herd of Friesian cows braving the swamp, line astern, while up to their udders in oozing mud and water, to all intents and purposes, crossing the Tamar from Devon into Cornwall.

Morwenstow, the first river Tamar borderland parish, is one of the most interesting places in this remote bleak corner of Cornwall. Strangely, there is no actual village but there are several hamlets, Woodford, Wolley, Gooseham, Shop, West Youlstone, Eastcott and Crosstown.

One of the most popular hostelries is the fifteenth-century Bush Inn. Over the decades since AD 950 it is believed to have been a retreat for monks, then

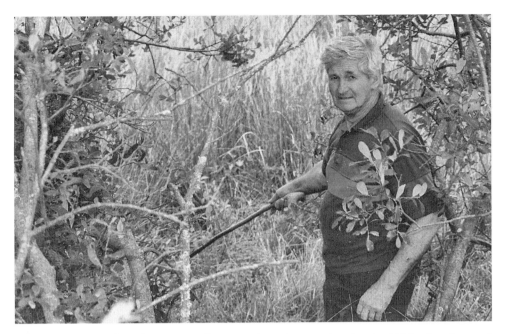

Gerald Fry where the infant Tamar discovers the culvert and makes its bid for freedom and escapes from the swamp.

in about 1400 it was a public house and farm. Later, the land was sold off and the house remained as an inn. In 1968 a fire destroyed the thatched roof, which has since been replaced with slate, and in June 2005 the Bush Inn came up for auction, for the first time in forty years.

In their day, the Grenville family were not without influence in this area. Stowe, the great family home, was built in 1679. It was four storeys high and had a window for every day of the year. No doubt the house was thought to be in keeping with the family's newly-elevated status, bestowed in recognition of their support for the monarchy during the Civil War. John Grenville had been raised to Earl of Bath, a Governor of Plymouth, Lord Lieutenant of Cornwall and a Privy Councillor. The last male Grenville heir died in 1711 and consequently the great house passed to Sir Bevill's daughter. In 1739, she decided that Stowe was to be demolished. Little other than grassy mounds remain to show where Stowe once stood. The Stowe Barton we see today, built with the stone salvaged from the former residence, is in private ownership.

Morwenstow is synonymous with the eccentric Victorian clergyman the Reverend Robert Stephen Hawker, who came to the parish as a young incumbent in 1834 and conducted his colourful and offbeat ministry in the

parish for over forty years. Today, over 130 years after his death, Hawker's name is still inseparable from the parish and the area, which has become known as Hawker Country. Hawker's trademark was his outlandish mode of dress. He always wore a large floppy hat, a fisherman's guernsey, baggy trousers tucked into thigh-length sea boots, turned down at the top, all beneath his surplice. He sometimes swathed himself in a large saffron coloured poncho. Hawker always drove himself around the parish in his pony and trap in what he fondly called his 'equipage'. If on foot he was accompanied by 'Gyp' his pet pig.

Soon after Hawker came to Morwenstow he set about putting his church, dedicated to St Morwenna and St John the Baptist, in good order and to rebuild his vicarage at his own expense. The spot was eventually determined when he spotted a flock of sheep sheltering in a hollow away from the wind roaring in off the Atlantic.

The most striking features of the vicarage is its chimneys, in the shapes of the church towers at Stratton, North Tamerton and Whitstone in which parishes he began his ministry. The kitchen chimney is in the shape of his mother's tomb. The church and its two-storey tower, mostly dating from the Norman period, stands like a sentinel looking out over the fields and is a landmark for shipping. The interior is well known for its array of carved sixteenth-century wooden bench-ends, and a thirteenth-century wall painting of St Morwenna. The Saxon font, which has an oval body banded round the middle with cable moulding, has a base of Polyphant stone of more recent date.

Standing in the churchyard and marking the grave of the crew of the Caledonia of Arbroath, wrecked on Sharpnose Point near Morwenstow in September 1843, is the ship's striking white carved wooden figurehead.

Hawker was a poet and he wrote his famous 'Trelawny' or the 'Song of the Western Men', now widely acknowledged as the Cornish national anthem, in his hut built from driftwood scavenged from the beach. Today it is one of the smallest properties owned by the National Trust.

In March 1938, the local newspaper, *The Bude and Stratton Post*, carried worrying news from Europe 'Mr Hitler invades Austria: profound shock'. Nearer home they reported '50,000 gas masks were being made every week', 'What to do in the event of an air-raid', 'A.R.P. personnel needed', 'Women were needed as ambulance drivers', 'The Duke of Cornwall's Light Infantry carrying out a recruiting drive with their guns on show'.

Around the same time it was announced that an anti-aircraft practice camp was to be established at Morwenstow. The Ministry of Defence had quickly requisitioned land for the site from Cleave farm, four miles from Bude. The camp was to be on the clifftop, some 400 feet above sea level where gun

emplacements would be sited. In February 1939 work began making the grassy strip and the first occupants arrived in May from Territorial Army units, as well as pilots and ground crews and aircraft flew in. The personnel lived in tents alongside the hangars on the south side of the airfield. When war came, the R.A.F. moved back in. Around this time a number of DH 82B unmanned radio-controlled aircraft, known as Queen Bees, came to R.A.F. Cleave, their main purpose being for target practice. Developed by De Havilland, these aircraft were developed in response to a request from the Air Ministry.

Later a naval crane and a steam catapult system was erected at Cleave, where there was a concrete plinth sticking out over the cliffs. From here the Queen Bees were launched and probably picked up by vessels from Padstow and Appledore. Later the system became outdated when launches were successfully made from the grassy landing strips. At one time the army camp on the northern side was partly occupied by American servicemen on anti-aircraft gunnery courses and occasionally the giant American heavy bombers flew into Cleave.

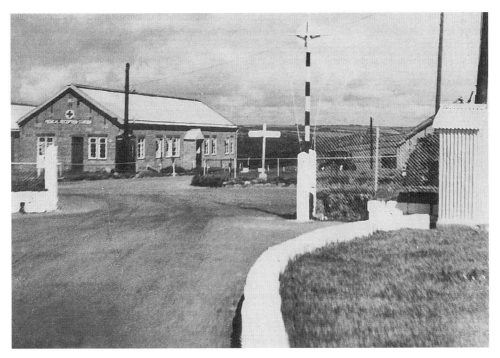

The entrance to R.A.F. Cleave Camp. Cleave Farm, Morwenstowe was purchased by the M.O.D. in 1938. Work on construction of the airfield high on the cliffs began in 1939. Cleave Farmhouse became the officers' mess, and the camp was on the south side of the airfield.

In August 1940, the Luftwaffe launched a raid against the airfield during which they dropped twelve bombs. As a result two Wallace aircraft were damaged and a civilian was injured. Later, a 1100lb bomb was dropped and landed near some hangars but fortunately it failed to explode. The airfield's closure was announced in May 1945. Within a few days most of the personnel had been posted and the camp reduced to 'care and maintenance'. Complete closure came in the following November. The land was owned by the Ministry of Defence who afterwards, in 1967, transferred it to the Ministry of Public Buildings and Works.

Cleave Camp was resuscitated in 1969 when it became a Combined Signals Organisation Station, built on what was part of Cleave Airfield. The building work was completed in 1972, two years later the station became fully equipped and operational and took on the name 'Morwenstow'. The site has continued to expand and a large number of dish aerials, the country's early warning network, dominates the cliff tops in this corner of the parish. In 2001 it was given another change of name and is currently known as GCHQ Bude. Today one of its main functions is communication, supporting UK, USA and NATO intelligence networks in the ever-present battle against terrorist attacks. It is still fondly referred to by older residents in Morwenstow as the 'Spy Station'.

Balancing Morwenstow on the other side of the Tamar's source and firmly in Devon is Bradworthy by the river Waldon, squeezed by two great rivers, the Torridge to the north the Tamar to the west. Bradworthy is mentioned in the Domesday Book and is one of the largest parishes in north Devon. It is believed by some to be of Celtic origin, from *Brae* (a hill) and *worthy* (upper or head) — being the hill at the end of the coombe. Other authorities attest that 'worthy' derives from the Anglo-Saxon for enclosure, making Bradworthy a broad enclosure.

The parish church is dedicated to St John the Baptist. In 1395, it was struck by lightning and by September 1400 it was restored and re-dedicated. Once there was a bell cote but in the early fifteenth century the tower was added. Inside there are several interesting features. The pulpit is thought to be Jacobean, the nave has a number of oak beams and there are some interesting windows.

During the seventeenth century, Bradworthy had a wayward vicar, by the name of William Lang. He was also the Sheriff's bailiff, a man with whom parishioners needed to keep in favour. Apparently Lang was not backward in forging warrants for the arrest of those to whom he took a dislike. Eventually his misdeeds were discovered and he fled to Ireland. This should have been the end of Lang as far as Bradworthy was concerned but later he was pardoned and afterwards resumed his former post as vicar of the parish. Apparently Lang did not change his ways. He scandalised the parish when he turned the vicarage

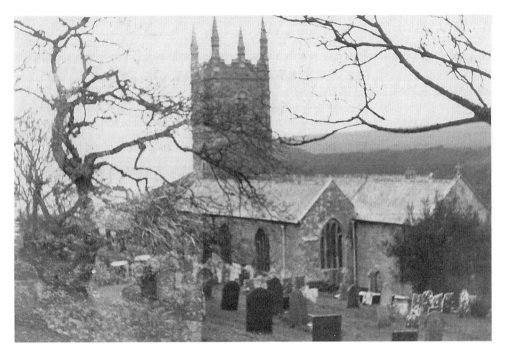

Morwenstowe church is the focal point of Hawker Country. Its tower is a landmark for shipping along the treacherous coast. Parson Hawker loved animals and allowed cats and dogs into his church. If anyone dared to complain, he'd retort that Noah took them into the ark so they had as much right to be there as anyone else.

into a public house, plotted against several parishioners and refused to baptise infants. Eventually he was arrested and imprisoned in London, where he died.

The square at Bradworthy, probably dating back to Saxon times, is one of the largest in the district and is a focal point of the village. At one time thatched cottages surrounded the square but there is only one thatched roof remaining, that of the Bradworthy Inn, once called the New Inn.

History tells us that there were two fairs, one in June and another in September, known as the sheep fair. Large flocks of sheep, sometimes numbering several thousand, were brought to the village to be sold. On fair days, stalls, cheap-jacks and amusements occupied part of the square but gradually fell victim to changing times. In 1997, the fair was revived in a modern way.

The centrepieces of the village today are the shelter, given by the Women's Institute to remember the fallen from the village in both the Great War and the Second World War, and the village pump, which commemorates Queen Victoria's Diamond Jubilee. Once there were two highly skilled blacksmiths in

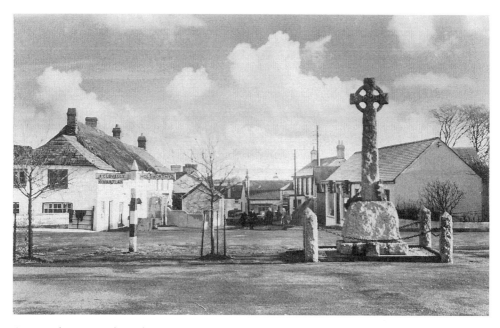

A quiet day in Bradworthy Square, one of the largest in North Devon. Over the years the thatched roofs have gradually dwindled. Years ago, on special fair days, the square was thronged with people going about their business.

the village, whose forges served the needs of the district's farming community. An amusing anecdote concerns one particular smithy. During the First World War it was fondly known as the war office, on account that parishioners could always hear how the war was progressing and in particular how the local young serving men were faring. The blacksmiths were always in great demand to attend weddings, being a symbol of good luck to the bride and her groom. The last working blacksmith's forge closed down within living memory.

Bradworthy, though an ancient settlement, has not stood still. Changes have always taken place. Cottages have been torn down, shops have changed their uses and the Temperance Hotel has become a private dwelling. The parish always seems to move with the times, not always in ways pleasing to everyone. Recently great controversy has surrounded the siting of three wind turbines at Stowford Cross known as Forestmoor Windfarm.

In recent years, Bradworthy has turned its eyes to tourism with the opening of a transport museum, housing nearly a hundred old road and farm vehicles — tractors, lorries, cars and motorcycles as well as oil cans, advertising signs and anything connected with transport in days now long gone.

Upper Tamar Lake, where the river is first harnessed to make the reservoir. It is now a popular recreational amenity for yachtsmen, wind surfers, canoeists, fishermen, walkers, or those who just want to sit, watch and enjoy the fresh air.

A mile or so after the infant Tamar has absconded from Woolley Barrows, it reaches its first bridge, which lies in a steep valley shrouded by trees between East and West Youlstone Farms. Once the bridge was humpbacked but it has since been levelled. It still carries a small country road under which the Tamar has suffered the ignominy of being forced into a concrete pipe! Soon the stream ripples under the bridges at Youlstone and Ruses Mill.

After a short distance it encounters Upper and Lower Tamar lake reservoirs, that supply the water system over large areas of north Cornwall and Devon. Construction work on the concrete gravity dam began in May 1973, by W. C. French (Construction) Ltd of Buckhurst Hill, Essex. The design and supervision of the work was carried out by consulting engineers Rofe, Kennard and Lapworth. In May 1975 the local press reported that the reservoir at Upper Tamar Lake was nearing completion and that the newest reservoir in Cornwall built for the South-West Water Authority would soon be impounding water. The reservoir became fully operational in 1977. It holds around 300 million gallons of water and its surface covers eighty-one acres. It supplies the mains system for consumers in the Bude district and to those in the Clovelly, Bradworthy and Warbstow areas.

Lower Tamar Lake dates from 1822, the heyday of the canal era, and was built by throwing an earth dam across the river, by the Bude Canal Company under an Act of Parliament dated 1819. Its main purpose was to serve as a feeder reservoir for the Bude Canal system. In 1951, it was designated a bird sanctuary. For some considerable time the future of the lake was in the balance, but in February 1975, at a meeting at Launceston, the fisheries and recreation committee of the South West Water Authority was able to report good news. Subject to minor work to the overspill and other maintenance being carried out, the engineer was now satisfied that the structure was safe and that he would be able to issue a safety certificate. Conditions were, however, imposed — on completion of the new dam, the old one should be abandoned.

On at least two occasions, in 1976 and again in 1986, severe drought conditions prevailed and the Lower Tamar Lake was used to top up the Bude water supply. In 1978 Lower Tamar Lake was withdrawn from use and it was proposed that the lake be drained to reduce its size from over eighty acres to around fifty acres, as a report had expressed concern about a leakage in the dam. In July 1995 the South West Water Authority announced new plans to reduce the size of the lake, and there was a public outcry as this second reduction came during one of the driest periods for several years. The reduction in size, however, would free the South West Water Authority from the escalating costs of flooding and maintenance. The Authority engineers found the lake to be particularly dangerous and it would have cost a vast amount to bring it up to modern standards, which was not justified as the lake had ceased to be part of the overall water supply system.

Lowering the water level would adversely affect the Bude Canal and put its future in jeopardy, so the Bude Canal Society offered to buy the lake for £1 and take over the responsibility for the dam. But the idea failed to materialise. South West Water Authority planned to turn fifty-one acres of the lake into a wetland nature reserve. Great numbers of fish would have to be transferred to Upper Tamar Lake. Today, the lake is a great leisure amenity and thousands of people visit it annually to sail, windsurf, fish, or to watch birds and it is here that the feeder arm of the old Bude Canal is first encountered.

The main canal was originally built to convey sea sand from the beaches at Bude to Helebridge by barge and then by tub boat to the wharves along its route. Later, farmers carried the sand by horse and cart to the countless farms around Holsworthy and Launceston.

Virworthy Wharf was once one of the busiest places on the canal and is firmly in Devon. Today one of the canal buildings has been turned into a visitor's centre and the wharf area has been cleared.

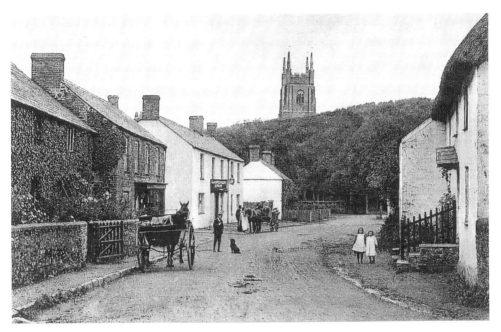

The centre of Kilkhampton village showing the London Inn. The church has memorials to the Grenville family and wooden carvings by locally-born man Michael Chuke, a pupil of Grinling Gibbons.

Chilchetone, Kilketon, Killockton or Kilkhampton, as we know it today, is the first sizeable place near the upper reaches of the river Tamar. The village church, dedicated to St James, is ninety-four feet in length with a magnificent entrance porch dating from 1567. Inside there are lofty roofs supported on slender granite pillars, a Jacobean pulpit, stained-glass windows, ancient bench ends and the Grenville chapel. From the top of the soaring tower there are expansive views for many miles, a fact that was not overlooked during the Second World War, when a Nazi invasion was expected. A local man, Mr Raymond Shaddick, recalls that the tower was a look-out post by the local Home Guard. There was a tarpaulin for shelter on the top and a telephone link to the nearby London Inn.

Below Tamar Lake visitors can see the Bude Aqueduct, which is still watered. At one time it conveyed water to the treatment works at Venn and then to Bude. The Stratton and Bude Urban District Council purchased the aqueduct on New Year's Day, 1902, for supplying water to both towns.

After Thurdon the county border escapes from the river Tamar and veers away overland. This is the first place where it is possible to pass between Devon

and Cornwall without crossing the Tamar, making Dexbeer Bridge the first to be wholly in Devon.

At Moreton Mill the Tamar grabs back the county border again, resumes its responsibility and flows on toward Burmsdon Aqueduct, which impressive feature carried the Bude canal over the river. Construction of the aqueduct started in 1821 and it took several men two or three years to complete the job. The bricks for building were brought from Redpost Brickworks.

Bude and Stratton are both within a short distance of the river Tamar. Stratton has a strong link with the Grenville family. Their Elizabethan manor house became the Tree Inn, a popular hostelry in the town, where Anthony Payne, the Cornish giant, was born in the seventeenth century. Payne senior was a tenant farmer of the Grenville's, and when Anthony reached twenty-one years of age he removed into the Grenville household at Stowe as a steward to Sir Beville. Anthony quickly grew to be over seven feet tall, with the body mass and strength to match. Apparently at Stowe, in addition to Payne's general duties, he was responsible for instructing the younger batch of Grenville boys and their companions in all the aspects of hunting, fishing and shooting, and

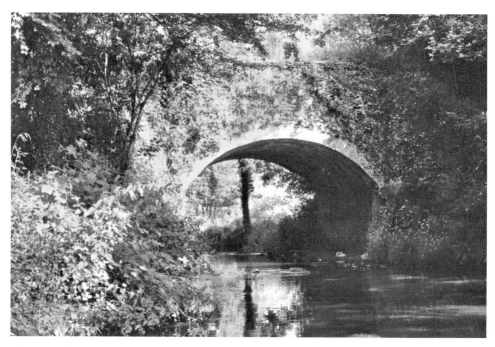

The magnificent single-arch Burmsdon Aqueduct, between Redpost and Vealand, which carries the old Bude Canal over the river Tamar.

Looking up the Great Plane at Hobbacott. Note the boat bays in the foreground. The plane is 935 feet in length and raises the canal 225 feet. There is public access to the plane but the farm, however, is private property. (Photograph Gerald Fry)

other country pastimes. Soon after the outbreak of the Civil War in 1642, Beville Grenville rallied his forces, and with Anthony Payne as his body guard was much to the fore on the battlefield. A local crisis arose when the Earl of Stamford and the Parliament forces flung themselves across the river Tamar, only a few miles away, in readiness to invade Cornwall. They later encamped on Stamford Hill, overlooking Stratton. The ensuing battle took place on 16 May 1643.

Between Stratton and the Tamar is Hobbacott Down, where Hobbacott Plane or The Great Plane is one of the wonders of the old Bude Canal. The plane was worked by water power, with two huge wells, each being 225 feet deep, at the top of an incline. The depth of the wells equalled the height of the incline from one canal level to the other. Each housed a giant bucket, over five feet in depth and ten feet across, capable of holding fifteen tons of water on the end of a chain wound over a drum. When one bucket rose, the other descended, hauling the iron-wheeled tub boats up or down the incline on iron rails.

At Red Post the canal takes a turn toward Launceston and will soon accompany the Tamar to Druxton.

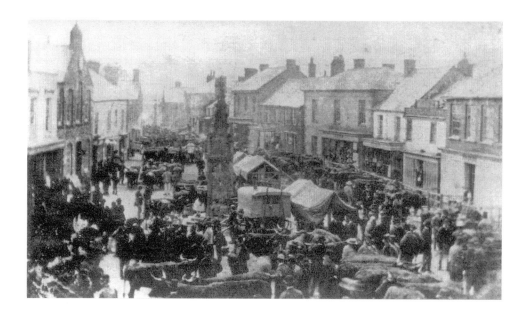

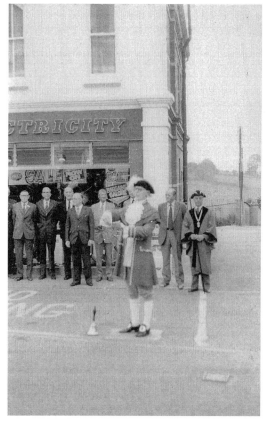

Above: Market Day in Holsworthy around the turn of the nineteenth century. At that time cattle were sold in the streets. Later a livestock market was built near the railway station. Both have now gone. Today stalls line the square and the range of goods for sale on market day has changed but Holsworthy is still a bustling business centre. (Picture courtesy of Holsworthy Museum)

Left: A popular Holsworthy citizen was Town Crier Bill 'Ginger' Matthews. The earliest reference to a town crier in Holsworthy comes in 1803. Bill Matthews took on the position in 1958. In 1975, he won the National Town Crier's Championship at Hastings and the title for being the best-dressed crier, bringing a unique double accolade back to Holsworthy. This picture shows Bill Matthews in action, crying the July St Peter's Fair open, on the corner of Stanhope Square.

Holsworthy, one of the thriving market towns of north Devon, is only a short distance from the Tamar. The town is famed for its annual St Peter's Fair, held in July, which is opened by the town crier standing on the spot where a great Elm once stood.

It is recorded that in 1809 Tamarstone Bridge had two Gothic-style brick arches and that the bridge structure was suspect. This was a matter of concern as the bridge carried the main road from Bude and Stratton to Holsworthy over the Tamar and also that the nearest railway station was at Holsworthy. Bude was without a railway until August 1898 and it closed in October 1966. In the *Cornish and Devon Post and Launceston Weekly News*, on 12 April 1819, it was reported that Tamarstone Bridge over the river Tamar was in a very weak condition and it had been so for a considerable time! The surveyor suggested that a letter be sent to Devon County Council with a view to taking some action if it should be necessary to rebuild it. Later a new bridge was built at Tamarstone and the highway realigned. The stone abutments of the previous bridge remain a few yards upstream and the Tamar flows on toward Bridgerule.

2

THE GATHERING STREAM

Below Tamarstone Bridge, the Tamar reaches Bridgerule, one of the earliest crossing places on the upper reaches of the river. According to old records there was a bridge here before the Norman Conquest, and in 1085 the Domesday Book records that one Ruald Asdobed held the manor of Brige. In the Launceston Cartulary the bridge was called *Pons Ruwold* on Tamara and by 1388 it has become *Brugge-rewell*.

Tradition has it that during the Stratton campaign in 1643, the earliest in the English Civil War, a skirmish between the Royalists and the Parliament forces took place here. Afterwards the bridge was washed away by floodwater and later replacement bridges also fell victim to the torrents. Most recently, one Sunday morning early in May 1923, Bridgerule residents woke to a shocking sight. The old bridge, a single span over the Tamar that had stood for around a hundred years, and which had been propped up with poles for many years and been considered unsafe for vehicular traffic, had collapsed. In the weeks prior to the collapse it had been noticed that the arch was gradually sinking and the villagers were fearful that a calamity might occur. For some the bridge collapse came as a blessing in disguise. As the school was on the opposite river bank from the village it was impossible for the pupils to get to their lessons, so they were given time off. The general inconvenience was considerable as the Tamar can only be forded here at low water, the banks being soft and the river bed uneven and dangerous. A temporary pedestrian crossing was quickly erected but it was still a great inconvenience, particularly for vehicular traffic wishing to get to the village or the railway station.

In July, Devon County Council placed a dam across the river to enable debris to be removed and preliminary work to be carried out before the

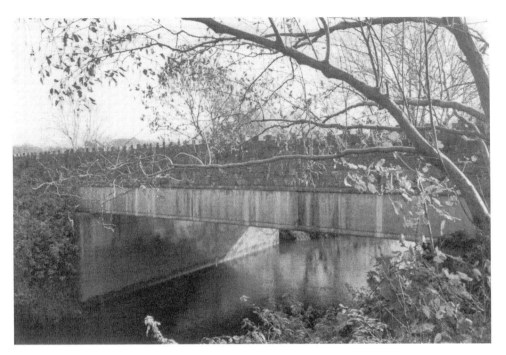

The Tamar flows gently under Tamarstone Bridge, which carries the main highway between Bude and Holsworthy.

commencement of rebuilding. The new bridge was to be constructed of reinforced concrete and Superintendent Mr Slattery was foreman of the project.

Here for a short distance the river Tamar abandons its duty of marking the border between Devon and Cornwall.

Tackbeare Manor, which dates from the time of the Domesday Book, was then in the possession of Count Robert of Mortain, half brother to William the Conqueror. From that time the house has a well-written history. Inside there are fine plaster-moulded ceilings, numerous reception rooms and bedrooms, mullion windows, great fireplaces and wooden panelling. In the eighteenth century Tackbeare was in the parish of Launcells and belonged to Mr Braddon, who with his neighbour Mr Harward of Newacott were concerned about the lack of employment for the men returning from the Napoleonic Wars. Around this time the Canal Age was dawning, and, by chance, Mr Braddon had in his possession the Nuttall plan for a canal from Bude to Holsworthy and Launceston. Braddon and Harward discussed the idea at Tackbeare. Braddon knew that Lord Stanhope was keen on the canal idea and broached the subject

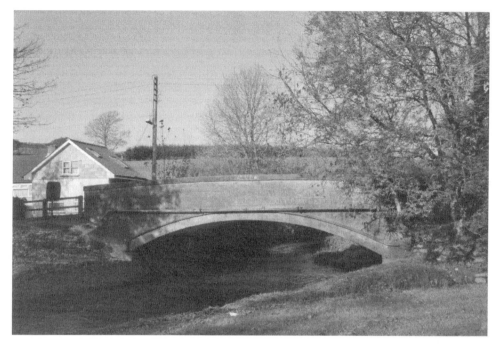

Over the decades several bridges in Bridgerule have been washed away by heavy flooding. This picture shows the newest bridge in the village, built in 1923, to replace that which collapsed.

to him. Lord Stanhope had supported an earlier scheme and did so again, and eventually the canal was built.

Proposed twentieth-century changes dictated that Tackbeare was placed firmly in the parish of Bridgerule in Devon where it remains today.

In 1966, the boundary commissioners decided that for the whole of its length the river Tamar should be the border between Devon and Cornwall. The fact that boundary changes would effectively cut Bridgerule parish in two seemed irrelevant. The Commissioners believed they knew what was best for Bridgerule people but soon after the official announcement the villagers were up in arms and were against any changes. Meetings were held, protests were mounted and strident voices were raised in objection. There was no way that Bridgerule people were going to become part of Cornwall, they were all Devonian and were determined to remain so! As a result of the strength of the protest the boundary commissioners were forced to give way and to reconsider their decision and, after protracted discussions, they agreed that Bridgerule should remain wholly in Devon. This victory, however, was short-lived. In less than twenty years the ugly spectre of boundary change again

Bridgerule Chapel standing almost on the river bank near the centre of the village which is balanced by the Bridge Inn located on the opposite side of the river.

raised its head. This time the villagers were better prepared and ready to fight even harder to oppose any changes and to remain in Devon. Sir Peter Mills, their Member of Parliament, was persuaded to put his weight behind the villager's campaign. The border dispute was resolved to the satisfaction of Bridgerule residents, as today the parish sits firmly in Devon. The border between Cornwall and Devon is no longer the Tamar but is crossed at Bevill's Hill and then, after a short distance, re-crossed at Jewell's Cross, both of whom are on the Launceston to Bude road.

The present village chapel at Bridgerule, opened in April 1907, stands by the bridge and only a few yards from the river Tamar. In earlier years, the local Bible Christian community quickly outgrew the original chapel and they required larger premises, and the building was also in need of urgent repair or replacement. After discussions between the trustees and the stewards it was decided to repair at a cost of around £200. However, soon after the work started it was discovered that the existing walls were dangerous. The stewards and trustees then decided to pull the building down and rebuild. On the appointed day great chains were put around the building and attached

to Mr Lucas' traction engine. The local newspaper, *The Launceston Weekly News*, tells how the engine gave a mighty pull and the building came crashing down. While the new chapel was being built the Bible Christian community conducted their worship in Mr Bray's barn.

The new chapel building was designed by Mr S. Parsons of Holsworthy in the Gothic style and was large enough to accommodate 140 worshippers. The complex also included schoolrooms, a preacher's vestry, a stable, carriage house, furnace and lavatory. The whole was enclosed by a stone wall and iron railings at a cost of around £625. At this time, a change of name was agreed. Instead of Bible Christian it became United Methodist, in deference to the forthcoming amalgamation of the New Connection, United Methodists and Bible Christians.

On the opening day, Messrs Budd and Sons provided free transport from the railway station, Messrs Hamley ran brakes from Holsworthy and Messrs Baily and Ashton provided their horse-drawn waggonettes. During a short outdoor service the Revd Thomas Braund officially opened the doors of the new building. At the indoor service extra seating had to be arranged. Later in the day a selection of photographs showing the earlier proceedings were on view in the window of Mr Vinnicombe's shop. Nearby is Bridge Mill and up the hill is the parish church. Across the river is the Bridge Inn.

There is a legend connected with Bridgerule. The story goes that one day, over 200 years ago, a tall dark handsome young man, travelling in a fine coach drawn by four magnificent black horses, arrived in the village. He was immediately attracted to a young girl who lived with her mother in a small cottage. By all accounts the attraction was mutual and quickly grew into something deeper and he started paying regular visits to her home to see her. Apparently plans were soon made for the girl to leave Bridgerule and then they would be married. The girl's mother became suspicious of the young man's identity and was concerned about losing her daughter to a stranger. Later the woman sought out the vicar and asked for his advice on the matter. The vicar advised the woman that he was certain that the young man was the devil in disguise. He took a consecrated candle from the altar and told her to light it when the young man called again, and ask him not to take her daughter away until the candle guttered and burnt out. The woman carefully explained the plan to her daughter and the next evening the young man arrived and asked the girl if she was ready to leave with him as she had promised. The girl pleaded for more time while she changed into some better clothes in readiness for the journey. The young man agreed to her request but his eagerness to be away was all too apparent. The girl's mother grabbed the candle and ran with it to the parish church where the vicar took it from her and secreted it in the

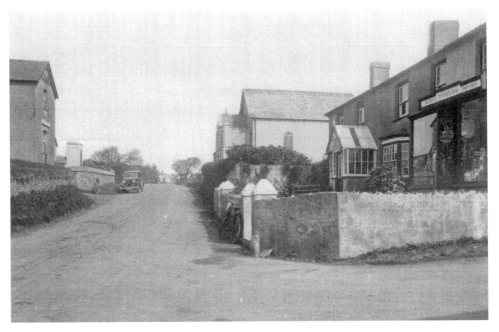

Whitstone village showing Pethick Brothers' Grocers and Provision Merchants shop, now the post office and general store. Note the old car and the uneven road surface. There were no speed restrictions then! Balsdon road, to the right, leads to Crowford Bridge, the Tamar and on to Holsworthy.

church wall where it is believed it remains to this day. Immediately, the young man realised that his ploy had failed he drove his carriage away at a reckless pace to Affaland Moor, where it left the track and ended up in a bog. Neither the young-man, his horses, or the carriage have ever been seen again!

Back on the Cornish bank, Whitstone village is a short distance from the growing Tamar.

Bennetts is a red-brick building set on high ground a short distance from the highway and was once the residence of the Hele family, and through marriage came to the Bassetts. In recent years it has become known as Whitstone Head School. In 1981, the school needed a new gymnasium and classrooms, and a group of enterprising students, under the guidance of master John Maughan, constructed a wooden bicycle from elm trees felled in the school grounds in order to undertake a sponsored fundraising bicycle ride. It was planned to ride the machine from Holsworthy to Lands End. What was known as '100 uncomfortable miles' took the group into Launceston where an impromptu 'ride-about' took place in the square. A team of boys, as well as Mr Maughan, took

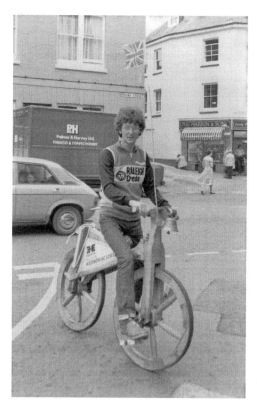

A pupil from Whitstone Head school with the wooden bicycle which a relay team rode from Holsworthy and eventually to Lands End. A bicycle 'ride- about' the square at Launceston Square in 1981 caused a lot of interest among shoppers, not to mention the disruption of the traffic flow, the square not being pedestrianised at that time.

it in turns to ride through Pipers Pool, Camelford, Wadebridge and on through Hayle. Despite indifferent weather they arrived safely at Lands End, and the ride was hailed a success. The then-headmaster, Mr John Ridger, is reported to have said that the boys 'raised well over their target sum and they showed a great sense of achievement'. Today Whitstone village has a school, chapel, and church. One of the highlights of the village year is the annual carnival, but sadly the renowned male voice choir was disbanded in May 2006.

1 November 1898 was a great day for both Whitstone and Bridgerule. Thanks to the efforts of Squire Mucklow, the London and South Western Railway arrived. The station was located between the two villages, hence its name, Whitstone and Bridgerule. One of the first people in February 1899 to make use of the new railway was Squire Mucklow. Apparently forty horses, each accompanied by a man, were being walked from Poundstock to the station, to be entrained to Peterborough. By all accounts there was difficulty in loading the horses into the boxes. Hundreds of people, some from as far away as Bude, converged on the station to witness the spectacle. Whitstone and Bridgerule

station became the 'in place' and several Bude merchants saw the advantage of having stores at Whitstone, among them W. W. Petherick, West Devon and North Cornwall Farmers, Bibby's and Vivian and Sons. During the Second World War, prior to the Normandy Landings in 1943, huge changes came to the station. The American Army urgently needed to establish a yard where they could receive vast quantities of ammunition. Whitstone and Bridgerule Station seemed to fit the bill. A loop was established which could cope with one locomotive and around thirty wagons, as ammunition was to be brought in by the trainload. Local people still recall this operation and can pinpoint where the ammunition dumps were by the side of the roads. After the landings, the loop gradually fell into disuse and was finally removed in March 1947.

Whitstone Brickworks was established in 1898 and was owned by Squire Glubb, who sold it to a Mr Morris, who later sold it to the West Country Brick Company and it became the Whitstone Brick and Tile Company Ltd. In its heyday the works, with its 120 foot landmark chimney, made over four million bricks annually. In March 1965, there was a slump in the demand for bricks, and the company found it impossible to continue trading. A number of men lost their jobs and the works finally closed in August the same year.

Once there was only a ford at Crowford on the Whitstone to Holsworthy road, until an incident occurred involving the Reverend R. H. Knighton, who was travelling to Holsworthy in his pony and trap. When he came to the ford the Tamar it was in full spate but he was determined to reach his destination and attempted to cross. Suddenly the reverend gentleman, together with his pony and trap, were swept downstream. Fortunately the vicar regained dry land and safety, and shortly afterwards, hearing of the vicar's ordeal, Squire Mucklow had the bridge built.

Further downstream at North Tamerton, where the river Deer is the first tributary of any size to add its offering to the Tamar and for a short distance takes charge of the county boundaries, makes the river bridge the first to be wholly in Cornwall.

It is recorded that once Tamerton Bridge had three or four arches and was mentioned by William of Worcester in 1478. In 1645/46 what is probably one of the fiercest Civil War skirmishes took place here and the royalists were routed.

The river Tamar has always been interwoven into the life of North Tamerton.

In November 1952, the river burst its banks, flooding the road to an impassable depth. The school log book records that for this reason only half of the pupils were present.

North Tamerton Bridge and Raggot Hill. Once the village post office was in the building on the far side. The bridge is one of the rarities, being a Tamar crossing standing wholly in Cornwall, the river Deer having snatched away control of the county border.

The old Bude canal passed through North Tamerton at a nearby bungalow, part of the canal line has been turned into a sunken garden. There is also a clutch of stone built canal store-houses. This is strictly on private property. At one time an aqueduct carried the canal over the public road.

Soon the river Claw from the Holsworthy area joins the Tamar, which flows below the line of the Bude canal, before it reaches Tamerton wheel pit and incline plane.

Below North Tamerton the river Tamar wanders on under picturesque Eastcott Bridge to Tetcott, threading its way into Arscott country.

The Arscott's, a Devon family came to Tetcott in the mid-sixteenth century. Here they built the manor which was reckoned to be one of the finest Queen Anne houses in the district.

When the last Arscott died in 1788, Tetcott Manor was bequeathed to Sir William Molesworth of Pencarrow, near Bodmin.

In 1831, William, a grandson of the legatee, found the responsibility of keeping two houses and estates overwhelming, and he decided to have Tetcott Manor torn down. Most of the contents and some of the fine wooden panelling

Extensive flooding, colloquially known as 'landwaters', roaring down the valley at North Tamerton. The bridge is shown in the centre of the picture.

was taken to Pencarrow. Later a large gothic-style shooting-lodge was built in adjoining woodland.

During the eighteenth century, the last Court Jester in the country lived at Tetcott Manor. He was known as Black John, a deformed, humped-back, diminutive dwarf who became a favourite of Squire John Arscott.

Black John is an enigma, neither his surname nor the exact year or place of his birth are known. He lived in a ramshackle hut near the kennels as he dearly loved following the hounds on foot. His diminutive stature and fleetness of foot, combined with his local knowledge, enabled him to keep up with the pack, consequently he was almost always in at a kill.

Contemporary accounts tell us that Squire Arscott's hunting parties were legendary. As part of the evening entertainment, Black John was expected to amuse the guests who must have been amazed at his turns! One was tying live mice together and then lowering them down his throat, then retrieving them. Another feat was known as Sparrow Mumbling! Apparently, Black John was adept at holding a live sparrow between his protruding teeth and being able to pluck every feather off the bird with his lips. One winter's day, so the story

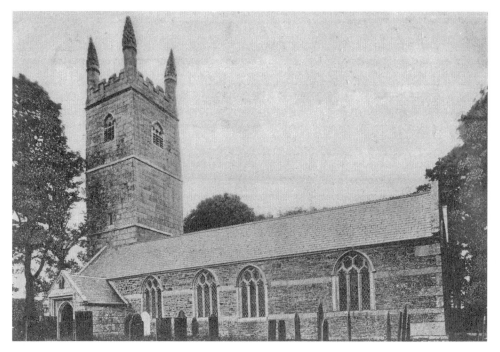

North Tamerton church, where Wesley preached and Hawker was a curate for a time.

goes, Black John disappeared in a snowstorm. Great concern was shown for the dwarf's safety and a posse of men went in search of him. Later Black John was found frozen stiff with cold lying under a snowdrift. He was pronounced dead on the spot and carried to the mansion. Days later during the funeral service, much to the concern of the Reverend Robert Martyn, who was officiating, and the assembled sympathisers, a loud banging was heard from inside the coffin. Black John had thawed out!

Black John placed the blame for being almost buried alive on the shoulders of the vicar and never afterwards trusted him. For fear that the vicar might try again, Black John refused to let Squire John Arscott out of his sight, knowing that with his master around he would be safe. After Arscott's death, Black John had to be dragged away from his master's grave. Black John later built a hut by the churchyard wall where he stayed, grieving for his master, until the end of his days.

During the Second World War, to escape the bombing of the large cities thousands of young children were evacuated to Devon and Cornwall. One teenager who has never been forgotten came from London and found himself along with other lads on a farm at Tetcott and Boyton, and for a time attended Launceston College. He was Roger Moore, now Sir Roger — well known on

Black John, the last Court Jester in the country, who lived at Tetcott Manor. Because of his odd ways and singular after-dinner 'antics' he became a legend in his own lifetime. (Photograph courtesy of Royal Institution of Cornwall — Truro)

television as The Saint and on the silver cinema screen as the first and greatest James Bond of them all.

The Tamar has always been considered a salmon fishing river but in 2006 concern was shown about the lack of suitable spawning beds on the upper reaches of the river, the old beds having become silted up or washed away, which adversely affected the stocks. The Atlantic Salmon Trust designed new beds in what they called the 'Newbury Riffle'. The gravel and pebbles were especially selected and cleaned before being placed in the river.

After Tetcott, on the Devon side, the river Tamar forces its way between Beardown plantation and Eastcott Wood and on to Luffincott, where of one Devon's greatest mysteries was played out.

Frank Parker, a bachelor with a commanding personality, a gentlemanly bearing and sober in his manner of dress, came as vicar to Luffincott in 1838. He built his vicarage, a large rambling thatched house, with bow windows, in the Strawberry Hill Gothic style, on land above a stream. Parker was a scholar who employed several servants indoors, including a cook-housekeeper, and outside, he employed a gardener handyman. Parker insisted that all his staff attend both Mattins and Evensong in the church daily, and to remind them,

he tolled the church bell each morning and evening. Parker was an eccentric who owned hundreds of books, which he forbade anyone to see, but he had a strong suspicion that the servant girls were secretly browsing them while he was in church. Once, to everyone's amazement, while delivering his sermon he suddenly left the pulpit and ran back to the rectory hoping to catch them red-handed. Whether or not he was successful remains a mystery.

Parker lived at Luffincott for forty-five years and he let it be known that when he died he wanted to be buried six feet deep, so that he could not rise again. Parker died, aged eighty years, on 3 April 1883 and was buried at Luffincott.

Strangely, the next few incumbents, Revd T. Morris, Revd S.C. Haines and the Revd H. Collins never stayed at Luffincott for long. The next incumbent, Browne, was hoping to settle at Luffincott as he was due to be married but, after furnishing the vicarage, he was suddenly jilted. Seemingly around this time, in the midst of eating a meal, he had a strange experience. Some accounts say it was the appearance of Parker's ghost, others believe it was something more sinister. Whatever it was, it unnerved Browne who fled from the rectory and ran the five or so miles to Clawton where he was previously curate. At

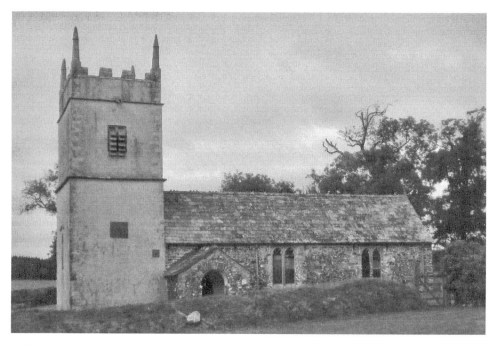

Luffincott vicarage where strange happenings that scared away the vicar took place, after which he never set foot inside the house again. He lies buried in the churchyard.

Clawton Browne was given shelter by a farmer's wife with whom he had lodged while attached to the parish and he remained there for the next dozen or so years. After Browne's unsettling experience at Luffincott, he refused to have any of his possessions removed from the rectory and he vowed never to enter the vicarage again. When a fellow-clergyman and the Archdeacon asked Browne what exactly had frightened him and his housekeeper at Luffincott he declined to answer, preferring to discuss anything connected with the parish other than his unfortunate experience. On Sundays and other times that services were held at Luffincott church, Browne drove himself, or was driven over, from Clawton in a pony and trap by a farmer friend. He always ate his lunch in the church porch. This part of the Tamar border land is fairly remote but news about the strange goings-on at Luffincott spread like wildfire and the vicarage soon became the centre of curiosity, people coming to peer in at the windows, to gape at Browne's belongings. According to the Reverend C. D. Kingdom, when he visited Luffincott soon after Browne's flight, there was silver cutlery and a half-eaten meal was on the table exactly where he had left it. Eventually it became evident that Browne never intended to return to his vicarage to claim his belongings, and they all began to disappear. Over time curious people began to spend nights at the vicarage in the hope of seeing a ghostly apparition.

Chapman's Well on the Launceston to Holsworthy road, a short distance from the Tamar, pictured in the 1950s. So far Chapman's Well seems to have escaped any rash of modern bungalow development.

Local memory recalls that two well-known and staid Boyton men, after fortifying themselves in the Arscott Arms inn at Chapman's Well, went to Luffincott rectory where they spent the night expecting to witness an apparition. Reportedly nothing strange happened but it was a relief when daylight came. Browne's troubled incumbency at Luffincott came to an abrupt end in the early 1900s, when the Diocesan authorities intervened. Both Browne and his housekeeper died without revealing anything of the incident. The story of the strange goings-on at Luffincott does not end here. Some years afterwards the house caught fire in suspicious circumstances and was burnt to the ground. So the mystery of Luffincott rectory remains!

The strengthening Tamar flows on, passing Hornacott Barton, Bradridge Wood and on toward Boyton.

3

BOYTON TO POLSON BRIDGE

Standing proudly above the river Tamar as it glides southwards, Boyton village is the centre of a parish steeped in history. Once the parish church belonged to Launceston Priory. Some of the structure dates from Norman times but by the late seventeenth century it was ruinous. A generous gift from Mr William Symons made the restoration possible. The church is dedicated to 'The Holy Name', and at one time, it was somewhat isolated apart from a few farms and a smattering of small cottages. Today it stands in close proximity to modern housing developments.

Early Methodism flourished in Boyton, and by 1888 the congregation had outgrown their premises and a new chapel was built. It was opened for worship in July 1889, when the Reverend R. Chew of Harrogate, who had a connection with Boyton, performed the official opening ceremony. The named bricks incorporated in the fabric of the porch read like a list of Boyton families through the decades.

There are several old houses in the parish, Beardon, Wilkie Down, Hornacott Manor, Temperance Farm and others, all of which are in private ownership and not open to the public. Interestingly, one Boyton lady has a memorial tablet in Exeter Cathedral. She is Agnes Prest, mother of two children, who lived at Northcott. During Queen Mary's turbulent reign it was decreed that the Catholic Mass be said in all churches. Agnes Prest, a Protestant, could not conform. Eventually she was arrested, imprisoned at Launceston, then stood trial at the Guildhall in Exeter and was convicted of heresy. She was burnt at the stake in Southernhaye, Exeter, in 1557.

Few people know anything about Nicholas Burd the Boyton Hermit, who was reputed to be a man of considerable means. He lived near the village in what was described, at the time of his death in 1879, as a miserable hovel. The

roof of his 'house' was almost off, the door was hanging down and there was no glass in the windows. Burd would seldom let anyone inside but it was known that there was no furniture, and no bed. Burd slept on the floor in a pile of rags and he had lived in this state for a number of years. Burd's everyday affairs were overseen by Nathaniel Reed of West Curry, who allowed him 10 shillings (50p) a week on which to live. Reed wanted to put the house back into good repair but Burd refused to have the work done. Burd was found dead from exposure having been last seen alive lying on the floor by a Samuel Sleeman.

At Boyton Bridge there are reminders of the Bude Canal. A grassed-over wharf area, a stretch of towpath and some stonework of the bridge, which carried the road over the canal, is evident. Travellers will spot part of a canal boundary stone incorporated as a garden feature into the wall surrounding a bungalow.

During the Second World War, there was a Timber Corp encampment down by the Tamar at Boyton Bridge. It was a familiar site at the time to see the 'Jills' working the heavy horses in the nearby woods, drawing the felled trees to the site sawmill on the river bank. The Nissen Hut, which was the camp bath house, is still in evidence. Mr William 'Bill' Dinner, who lives a short distance from the river, still recalls that when he was a youngster the 'Jills' travelled to and from the Arscott Arms at Chapman's Well, their nearest hostelry, in an old truck.

Once Boyton Bridge over the Tamar was a wooden concern, which was eventually superseded by a more substantial stone structure. The foundations of this crossing were only discovered in 1975 after the stone and cast-iron bridge, which had done its duty for over a hundred years, was deemed unsafe to cope with the weight and volume of modern-day traffic and the Tamar was drained for bridge strengthening. In 2005 over a period of six weeks Cormac contractors replaced Boyton Bridge, which is now expected to last for another 125 years. During the bridge construction a temporary pathway was laid adjoining the new structure to enable a local farmer, the late Mr Mervyn Horrell, to move his sheep, whenever necessary, across the river from one part of his farm to the other, effectively from Cornwall into Devon. The official opening of the bridge came on the morning of Friday 15 April, and the ceremony was attended by local councillors and residents. At the time of writing, August 2009, there is one omission here at Boyton Bridge. The major borderland crossings of the Tamar mostly proudly announce in the Cornish language that the traveller is, in fact, entering Cornwall. Not so at Boyton Bridge! For some strange reason Boyton Bridge seems to have been downgraded. Interestingly, set into the masonry on the Cornish end of the of the bridge is an old cast-iron Cornwall County Council plaque, warning locomotive drivers about the weight limit on

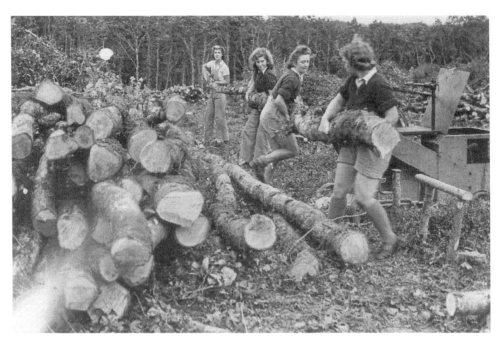

During the Second World War the Timber Corp 'Jills' undertook hard, heavy work in the woods at Boyton Bridge. (W. Dinner Collection)

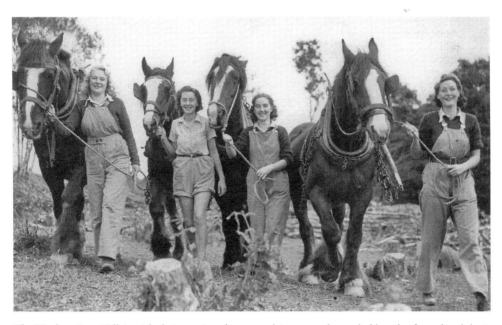

The Timber Corp 'Jills', with their equine charges, taking a much-needed break after a hard day's work at Boyton Bridge. (W. Dinner Collection)

Boyton Bridge over the Tamar, as it was until it was recently replaced. At one time it was a favourite meeting place of the Dartmoor Otter Hounds. (Picture by George Ellis)

A quiet period during the programme to replace Boyton Bridge. The road surface has been removed revealing the rusting iron girders.

the bridge and asking them to seek permission to cross. A similar notice from Devon County Council, also built into the bridge at the Devon end, gives similar warning, making Boyton Bridge a definite border crossing, and indicating that both County Councils agree and there can be no arguing with them!

Nearby, hidden behind a bush, stands a slate stone incised with a capital letter 'C' indicating that the County Council was responsible for the upkeep of the bridge. Immediately on the end of the bridge a lane leads to Boyton Mill, which was in regular use until the outbreak of the Second World War. The last miller was Mr Cole, whose family lived at Boyton Mill until 1961.

In the 1960s, Boyton Bridge was a popular meeting place for the Dartmoor Otter Hounds, which name they have carried since 1825. They are one of the oldest packs in the country. At one time, they were based near Bow in Devon, under the Mastership of Major Geoffrey Mott, Harvey Cole and Miss K. Y. Varndell.

Firmly putting Boyton Bridge behind it, the Tamar and the old Bude Canal continue to travel on in close proximity. Shortly, the pair reach Bridgetown, twenty miles from the start of the canal. Here, high above the river, is one of the most interesting structures on this section of the canal. This is the Werrington Incline Plane, one of only six such structures on the Bude Canal system. It is 295 feet long and raises the canal around 51 feet. This great feat of Victorian engineering allowed tub boats, both laden and empty, to be hauled up and lowered down on two sets of rails by water power, issuing from the nearby waterwheel pit. The tub boats were raised up from the canal, near the river Tamar in the valley, to another section of the canal on a higher level of the waterway and were then able to continue on their journey. Another remarkable feature is the beautiful stone arch which carries the incline over a public road, the only one on the Bude Canal to do so. At the top stands the plane-keepers cottage looking very much as it did when the canal was in its heyday.

Shortly afterwards the Tamar is joined by the Tala Water, over which a small aqueduct brings the canal to Druxton Wharf or, more correctly, Crossgates. This was the terminus of the Launceston arm of the Bude Canal, which was a real hive of activity. Here stood a whole range of canal buildings, including stores, stabling, the wharf-fingers cottage and, close at hand, the Canal Inn. In recent years, some of the buildings have been converted, though outwardly they still retain their distinctive canal 'look', while other buildings have been demolished.

Not many years ago it was still possible to trace the towpath and to define the wharf area. The sharp-eyed could still pick up lumps of culm which had fallen off the tub boats or been discarded for some other reason. Here, a hundred yards or so away, the old canal is deserted by the Tamar as it flows under historic *Durkeston Brugge*, Druxton Bridge, which strides over the river. The

Twenty miles from Bude the Werrington, or Bridgetown, Incline Plane, part of the Bude Canal system. It raised the canal from where it ran close to the Tamar up over a public road. The iron-wheeled tub boats were hauled up the incline on rails by water-power and then floated off on the next stretch of the canal. The plane-keepers cottage stands at the top of the incline.

bridge has four arches and dates from AD 1370. As well as its border duties separating Devon from Cornwall it also divides the parish of St Giles on the Heath from Werrington. The bridge also has a singular claim to fame.

Around 1370, a tithing man complained that *Boleputte Bridge*, Bullapitt Bridge, over the Tala Water, near where it joins the Tamar, was in a poor state of repair and was dangerous. Fearing a tragedy, he approached the Prior of Launceston and requested that the bridge be made safe. Contemporary writing tells us that the prior was somewhat irritated by the request and the unexpected expense that was likely to fall on his foundation. He obviously took the cost into account and he declined to pay for the work. The tithing man was equally strong-willed and was not going to be fobbed off. He brought the matter to the Hundred Court of Black Torrington. The sheriff afterwards ordered the bailiff to form a jury and to hold an inquest into the dispute. Druxton Bridge was deemed to be the most suitable place to conduct the proceedings, so on the appointed day the sheriff duly heard all the evidence for and against the claim. After much deliberation he

Box's Shop or St Giles on the Heath post office still retains its thatched roof. Today a part of the building is the appropriately named Pint and Post public house.

eventually came down firmly on the side of the prior and absolved him and his foundation from any responsibility for the upkeep of Bullapit Bridge.

The next Tamar tributary is the river Ottery (its local pronunciation is Attery) flowing down from Otterham parish in deepest north Cornwall and then, by way of Egloskerry and North Petherwin and Werrington as it makes its way toward the Tamar. It was the river Ottery which, until border changes in 1965, allowed an irritating tongue of Devon to poke into Cornwall. On its way to the Tamar, the Ottery effectively cuts the Werrington Park estate in two, but White Bridge gives private vehicular access to the mansion from the Launceston side.

One of the earliest references to Werrington Park comes from Saxon times. Over the centuries, the mansion has had numerous owners, among them Sir Francis Drake, nephew of the great Elizabethan navigator; the Duke of Northumberland and the Morice family. It was the Morice family who made the most radical changes to Werrington. The parish church originally stood near the mansion and well within the park but William Morice wanted to extend his bowling green, so he had the church pulled down, much to the anger of the parishioners who cursed the family and from which they never recovered.

The replacement church we see today was built just outside the confines of the park and consecrated in 1743. The church is unique in the fact that it has a

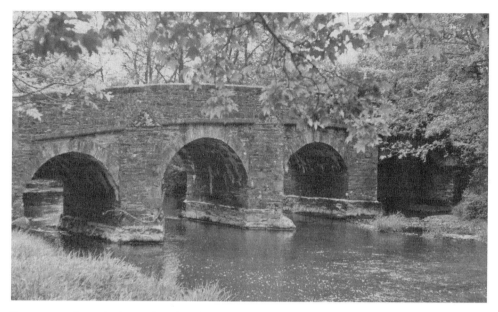

Druxton Bridge, which stands only a few yards from the terminus of the Launceston branch of the Bude Canal where it finally parts company from the river Tamar. In the fourteenth century an inquest concerning the upkeep of a nearby bridge, involving the Prior of Launceston Priory, took place on the bridge.

main tower, flanked on either side by two replica towers of solid stone. It also has several niches, in which are set figures of the saints and apostles. Sadly, the church fell victim to over-zealous Victorians with a passion for restoration. On the exterior north wall there is something of a treasure. It is a slate slab remembering Philip Scipio, a black African slave. Fortunately, the slate, being one of less than a dozen such stones in the entire country, was rescued after being used as a paving stone.

Scipio was brought to Werrington as a slave to the Duke of Wharton and then, when Wharton disappeared from Werrington, he left Scipio behind. Fortunately, Scipio was 'taken up' by Lady Morice as her personal assistant and evidently her Ladyship thought very highly of him. This is manifest because when Scipio died in 1743, she commissioned the slate memorial to him, which to this day keeps his name and memory green.

In 1822, Werrington Park was purchased by the Williams family of Caerhays Castle in Cornwall, and from that time until the present day it has remained in the same ownership. It is documented that during the years of the First World War, Werrington Park mansion was taken over and did sterling service as a Red

Werrington Park, standing aloof above the River Ottery but barely a mile from the Tamar, has a long and well documented history. In the eleventh century, it belonged to Gytha, mother of Harold, the last Saxon king, then came to the Abbots of Tavistock and the Duke of Bedford, followed by a string of notable owners, including Sir Francis Drake, Bart, nephew of the great Elizabethan navigator. In 1822, the Williams family purchased Werrington Park, and they still remain the present owners.

Cross auxiliary home hospital, treating up to around thirty patients at any one time. During the Second World War, the house served a different role as the headquarters of a Royal Artillery Company. In 1974, the Elizabethan part of the house was destroyed by fire but it has since been restored.

Beyond Werrington Park the Ottery flows under Ham Mill Bridge and a short distance away joins the Tamar. The Tamar flows on through lush pastureland and greets the new Nether Bridge and Higher New Bridge. The former is one of the most recent Tamar crossings and was officially opened in April 1986 by Christopher Beazeley M.E.P. It carries the Launceston to Holsworthy road over the river. In March 2008, Vanessa Beeman, Grand Bard of the Cornish Gorsedd, unveiled here one of the new 'Welcome to Cornwall' signs in the Cornish Language, reading *Kernow A'gas Dynergh*. These have been erected on most of the river Tamar crossings from Devon into Cornwall.

A few yards downstream in what is now a quiet backwater away from the ravages of modern traffic is Higher New Bridge, which dates from 1504, built by the Abbots of Tavistock who at the time owned large tracts of land hereabouts. A stone in the centre of the bridge tells that it is exactly two miles

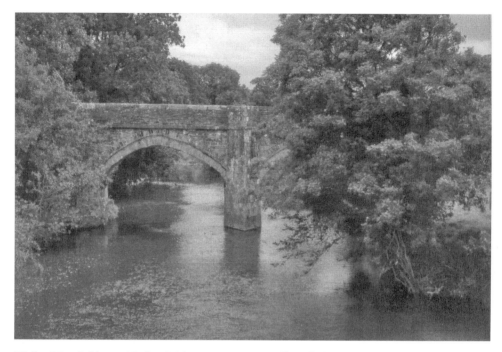

Higher New Bridge or Nether Bridge, as it was generally called, on a fine August day.

from the centre of Launceston. This bridge has been known unofficially as Netherbridge but, according to a Cornwall County Council plaque, it is now officially known as Higher New Bridge, its original name, to differentiate it from New Bridge at Gunnislake.

This granite-built bridge is twenty-eight feet over the water level and boasts three round arches, each twenty-five feet in span. It was built to replace an even earlier bridge, small parts of which remain some distance upstream from the newer structure. The bridge is mentioned in the Launceston Borough Rolls in 1437 and again in 1504, when one Bishop Oldham granted indulgences to all penitents who contributed to the cost of building the bridge. In 1644, Higher New Bridge, like most of the other Tamar bridges, saw a clash between the rival Royalist and Parliament troops under the commands of, respectively, Sir Richard Grenville and the Earl of Essex.

A short distance away was the site of what was fondly known as the Dutson brickworks, originally established by a Mr Taylor as a limited company in the 1920s, after suitable clay for making bricks was discovered by the Tamar. The orange-yellowish clay bricks were burnt in beehive kilns. Vast quantities of drainpipes and roofing tiles were also made at Dutson. Later, it became part

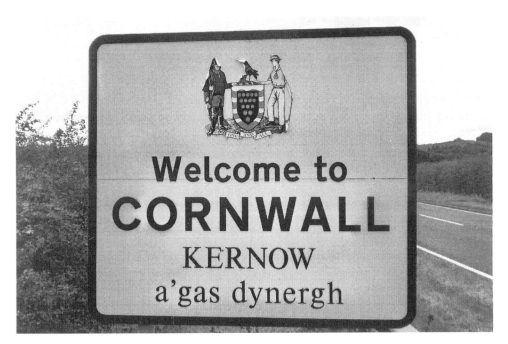

One of a number of 'Welcome to Cornwall' signs which greet the traveller in the Cornish language on several of the Tamar border bridges.

of the Western Counties Brick Company. According to a Mr Soper, one of the promoters, when interviewed by the local newspaper, inexhaustible beds of the finest clay in the district had been discovered. He described it as being 'as white as Candy'. On one side of the field there is a pit where old handmade bricks had been found, which had almost certainly been made by hand on the site as they had not been through the same manufacturing processes as modern bricks.

Apparently, research at the time revealed that bricks used in connection with building work for the Bude Canal were probably made here and also that a man from London had a brickworks operating on the site in the early years of the nineteenth century. This being the case, Mr Soper suggested that the bricks used for building many of the grand houses in Launceston and district came from Dutson. In 1920, there were twenty men employed at Dutson, mostly involved in removing the ten inches or so of superficial soil from the clay beds, which were of considerable depth. In May 1920, on a site near the clay beds, there was a concrete building in the course of construction. Three larger buildings were eventually built to house machinery, which would be driven by steam power. The machinery will prepare, cut and mould the clay, which will be hauled from the pit and moved over an incline to a second chamber and on

to a wire-cutting machine, which automatically cut the clay into the required sizes according to the items being made.

Mr Soper said that there was a great demand for bricks, which would eventually replace stone and, in any event, most of the local stone quarries were moving towards being worked out.

Another advantage for his enterprise was that most builders would rather handle bricks as they were of a standard size, rather than stone which was irregular. It was also generally considered that houses built of brick were dryer and warmer than those built of stone. The company intended to build houses for all their workforce and to that end they had already built a bungalow at the top of Dutson Hill, which was occupied by the foreman of the works.

The works closed in the 1930s and was later mostly torn down, leaving the square 105 foot chimney standing as a reminder until it too was demolished in the late 1950s.

On high ground, in a wedge of land at St Giles on the Heath, between where the river Tamar leaves Higher New Bridge and where it is joined by the river Carey is one of the most unusual homes anywhere along the Tamar.

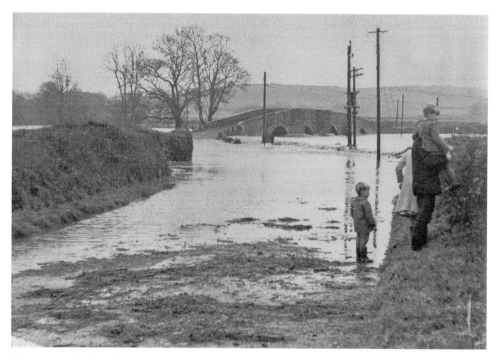

Flooding at Higher New Bridge in 1969. The photograph was taken from the Devon side of the river. (Photograph Henry Westlake)

Situated on a wedge of land between the rivers Carey and Tamar stands Raddon's Bungalow, a converted railway carriage, for many years the home of Mr and Mrs Wilfred Parnall.

Known as Raddons Bungalow, it was a redundant third class carriage of the London South Western Railway propped up on blocks. Mr and Mrs Wilfred Parnell bought the carriage together with two acres of land for around £65 in 1937. Over the decades, Mr Parnell painted the carriage bright red. He cleverly converted it to incorporate all modern amenities and it became more like a palace, boasting two bedrooms, a kitchen, bathroom, living room, and all modern amenities. The garden was always immaculate and a seasonal riot of colour. Some years ago, Mrs Ivy Parnell, a well-loved octogenarian, with a mind as sharp as a needle, who was always smiling and revelled in the nickname of 'Smiling Annie' and had lived in her railway carriage palace for around sixty years, found herself in dispute with a local farmer. The disagreement centred around who exactly owned the land on which the railway carriage was standing. A lengthy legal wrangle ensued and judgement finally came in favour of Mrs Parnell.

Flowing gently on, the river Tamar is soon joined by the river Carey from the Devon side and united they flow on towards Polson Bridge. After passing through Newport, Launceston, the Kensey joins the Tamar just prior to this

bridge. This is one of the Tamar's great little tributaries, rising on Keyrse moor, near Treneglos, a few miles from the north Cornwall coast and, having made a fourteen mile course, eventually flowing through Newport in the valley below Launceston. It was the lifeblood of the area, powering several enterprises including milling, iron-founding and tanning which were located nearby.

Today, the Kensey still passes close by the Augustinian Priory ruins and St Thomas' church, and under the five-arch thirteenth-century, single file Prior's Bridge, and then passes riverside, birthplace of the poet Charles Causley, beside the Launceston Steam Railway.

Further downstream stands St Leonard's Bridge and the site of the twelfth-century leper hospital. In September 1995, some workmen undertaking work connected with a drainage scheme discovered several skeletons. The site was later excavated by the celebrated BBC *Time Team*, headed by Tony Robinson. The remains, which were believed to date from the Civil War period, were later interred in St Thomas' churchyard. Here, too, is the famous St Leonard's Equitation Centre and, just beyond by Polson Bridge, the Kensey proudly adds its contribution to the Tamar.

4

POLSON BRIDGE TO GREYSTONE

Polston, Polstonel, Poulston Brygge, or Polson Bridge, as we know it today, has a royal connection, which gives it the greatest status of all the bridges that straddle the Tamar. It is the first bridge on the Tamar to be recorded and the lowest point at which the river can be forded. It stands where the old main A30 highway from Okehampton through Lifton to Launceston slides steeply down through heavily-wooded banks to the river.

From an entry in the Launceston Borough accounts for 1466-67 it seems that Launceston paid for the upkeep of the bridge. When the Bishop of Exeter visited Launceston he was so taken by the entertainment that he granted an indulgence of forty days to all penitents who contributed towards the upkeep of the bridge. There is a legend concerning the bridge which is related by Fuller. He writes that standing on Polson bridge there is a giant of a man of phenomenal height and strength who holds a black bill in his hand, waiting his chance to knock down any lawyers who try to enter Cornwall. Seemingly the giant had some uncanny way of discovering who was a lawyer and who was not and whether or not they intended to live in Cornwall.

It is here that, since the fourteenth century, the Duke of Cornwall, on crossing the bridge to visit his Duchy, receives his feudal dues — two white greyhounds, a pound of pepper, cumin, one hundred shillings, a salmon spear, a faggot of wood and a grey cloak to be carried by a steward wherever the Duke goes in the county and for however long his visit. These are presented from various manors and landowners in the county. Eventually, the custom lapsed but was revived again in 1909, when the royal visitors were met by Lord and Lady Clifden of Lanhydrock, and the Honourable Thomas Agar Robartes. Lord Clifden, as Lord of Lanhydrock, was bound by tradition to provide the duke with a grey riding cloak for his use on every occasion of

his visiting the duchy. On this occasion, the grey cloak was actually presented and placed on the prince's shoulders while he was on Polson Bridge during a brief stop, by Mrs Lygon Cocks, a duchy tenant. In 1937, all the feudal dues were presented on Launceston Castle Green and in 1973 the ceremony took place at the castle entrance. Some of the dues can be seen in a special display cabinet in Launceston's Lawrence House Museum. Incidentally, there are only 99 shillings. The prince slipped one in his top pocket and decided to keep it as a memento!

During the Napoleonic Wars (1793-1815), Launceston was a parole town and the centre of Polson Bridge marked the edge of the Launceston parole area, hence the bridge's singular duty. It was not unknown for local people when in the vicinity of the bridge to try to entice an unsuspecting prisoner to cross the bridge and so break his parole. By all accounts, if a prisoner was seen outside the limits of the parole area, or could be enticed to step outside it, then any person was at liberty to report the offence to the appropriate authorities and claim a reward… and some did! As punishment the prisoner was probably sent back to Dartmoor prison.

In the middle of the nineteenth century, a new bridge was built at Polson. William of Worcester tells us that the old bridge had been built at public expense and was 'a large fair stone fabric' and was similar to Greystone Bridge. Apparently the previous bridge at Polson was built of granite, and it is recorded that there was a weakness in the structure. Later on, it was deemed to be too narrow and could not cope with the continual increase in traffic between London, Exeter and Falmouth. During the winter of 1828, this was emphasised when a coach and horses belonging to Mr Smith of the King's Arms in Southgate, Launceston, was returning from Okehampton to Launceston and was washed away by the flood at Polson, as seemingly the entrance to the bridge was too narrow. Sadly, the horses were drowned but the driver was saved.

A few years later, a curious mishap took place while the new bridge was being built at the joint expenses of Devon and Cornwall. Robbins, the eminent Launceston historian, tells that late one night a mail coach halted, as usual, at the Arundell Arms at Lifton. The driver, guard and passengers dismounted, leaving one passenger, a Mr Wilson, agent to the Duke of Northumberland, aboard the coach. Apparently, the horses took fright and bolted. Both the horses and the coach crossed on the temporary wooden bridge at Polson without incident and afterwards halted at their customary place outside the White Hart Hotel in Launceston. Minutes later, the guard, Cornelius Crowhurst, who had leapt astride another mount, rode into town. To his relief, the mail was safe, the horses unharmed and the coach undamaged.

In Victorian times, Polson Bridge was partially demolished and only the three floodwater arches on the Cornish bank were left standing and were later incorporated into the rebuild, a structure of iron girders and reinforced concrete faced with stone.

About seventy years ago, Mr Murray Williams remembers that Polson Bridge was often the place for Launceston's daring young men to congregate. The challenge was always thrown down to find the guy brave enough to ride his bicycle along the full length of the parapet of the bridge. In 1933, the future of Polson Bridge was questioned, as there had been several recent motor accidents. A meeting of the Devon County Council roads committee at Exeter was convened to discuss the general condition of the bridge and the awkward approach from the Devon side. Letters between the Ministry of Transport and the various committees on both councils were exchanged, drawing attention to the condition of the bridge. An early conference with an engineer from the Ministry of Transport and Cornwall County Council was requested with a view the immediate carrying out of permanent repairs and the rebuilding of Polson Bridge.

Later, the County Surveyor submitted a scheme for the work at a cost of £17,000 and, if the weather was favourable during the time that the work was

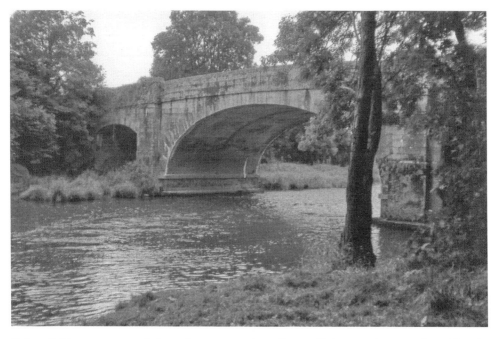

Polson Bridge, once one of the main entrances into Cornwall, has royal connections. Here in former times the feudal dues were presented to the Duke of Cornwall.

taking place, then the cost would not be so much. The proportion of the costs payable by each county was an obstacle and Devon County Council would only consider the scheme on the condition that improvements were made to the awkward approach down to the bridge on their side. Eventually it was agreed that the chairman and the county surveyor attend a conference and report back to the committee. It transpired that there was no real cause for alarm but work should be carried out on the central span without delay.

In October 1933, further discussions between Cornwall County roads committee and Devon County Council took place, regarding the replacement of the cast-iron structure with steelwork and iron railings at a cost of £3,000 or the construction of an entirely new bridge on a better line for £17,000. They also considered the surveyor's suggestion of partial rebuilding on the existing line with a granite-faced reinforced concrete arch, providing a 20 foot carriageway and a 5 foot footpath. The rebuilding was scheduled in the financial year 1934-1934.

Up until about twenty years ago, during the summer months the volume of holiday traffic moving nose to tail approaching Polson Bridge from both directions was horrendous but this has been relieved by the newer Dunheved Bridge taking the Launceston by pass over the Tamar.

In 1497, the Cornish rebelled against the heavy taxes levied by Henry VII to raise revenue to pay for his war against the Scots. The Cornish Host, as they were called, some 15,000 strong, led by Michael An Gof, a blacksmith from St Keverne on the Lizard Peninsula, together with Joseph Flamank, a lawyer from Bodmin, intended to march to London to register their grievance. The Cornish were confronted at Blackheath by King Henry's forces and by the evening hundreds lay either dead or dying. The Cornish ringleaders were later hung, drawn and quartered at Tyburn.

In May and June 1997, the 'Keskerdh Kernow 500 March' to commemorate the uprising, following on the original route, arrived in Launceston. The next morning, 31 May, the eighth day of the march, the focus was on Polson Bridge. The marchers left Launceston and headed towards the bridge. Several hundred marchers bearing flags and banners, in a sea of black and white, the Cornish colours, made a moving site as they crossed the river Tamar into Devon on their way to Blackheath.

At one time, those brave souls, known as the 'End to Enders', who walked or by using a wide variety of transport, travelled from John o Groats to Land's End, entered Cornwall at Polson Bridge and came into Launceston by the great bulk of the Southgate Arch.

The last great occasion was in 1960 when numerous people, including Dr Barbara Moor, Wendy Lewis, and a handful of local people, took part in the

Marchers on the 1997 Kesderdh Kernow 500 March, in high spirits as they leave Launceston by way of the Southgate Arch, on their way to Polson bridge to cross the River Tamar into Devon and on toward London. The King's forces decimated the rebels at Blackheath.

Billy Butlin walk. Nowadays, the 'End to Enders' passing through the town are few, most preferring the bypass route! There are exceptions, however, as was the case in November 1999 when Ian Botham, as he then was, was raising money on one of his famous long-distance charity walks. He was met at Polson Bridge and strode through the town to receive a tremendous Launceston welcome.

Polson Bridge is the home of the Launceston Rugby team, the 'Cornish All Blacks' as they have been known for many years, regardless of what other people or even other 'country's' may say or threaten to do.

For nearly thirty years, the Launceston Steam and Vintage Rally has taken over the rugby field at Polson Bridge, for their display of classic cars, steam engines, steam lorries and other related pastimes. Sadly, the rally was relocated in 2009, so the town is no longer thrilled in the evening by the sudden sight or sound of a traction engine undertaking an impromptu evening excursion round the town!

Below Polson Bridge, the Tamar was straddled by Chain Bridge, once a favourite spot for swimming and picnics. Chain Bridge, constructed by chains slung across the river and a wooden footbridge of separate planks fastened to the main linkage with shorter chains, must have been the flimsiest bridge to cross the Tamar. It was completely destroyed several years ago and all that remains are the bases to which the chains were anchored.

On a fine summer evening in June 1893, Launceston was dismayed when news reached the town that a young lad had been drowned in the Tamar near Chain Bridge. The youngster was Douglas Marshall, the son of business people in the town, who had been given permission to swim in the Tamar, near Chain Bridge, with a group of boys and their masters from Launceston College. Swimming in the Tamar was an activity which had been enjoyed for around twenty years. Young Marshall, according to contemporary reports, was an inexperienced swimmer and suddenly found himself out of his depth. Gallant rescue attempts were made by the boys to save their friend, particularly by one named Dawe who put his own life in danger and had to be rescued himself. Dr Gibson, who was quickly on the scene, dived several times to try to retrieve Marshall's body, until forced to give up. A man named Jennings, who happened to be outside the Westgate Inn, heard of the tragedy and hurried to Chain

Chain Bridge must have been one of the flimsiest crossings over the Tamar. It was often washed away by winter floods. Only the bases, which secured the chains, remain.

Bridge and immediately dived into the river and retrieved the body. A rowing boat belonging to Mr Bradshaw of Lifton Park had been brought to the scene and was used to bring Mr Jennings and the body to the Cornish bank.

In 1991, Dunheved Bridge, one of the newer Tamar crossing points, was lined with crowds of people waving black and gold flags and banners, eager to welcome home the Cornish Rugby team who had won victory in the County Championship of England at Twickenham.

Near here, the Tamar makes a great sweeping turn to meet up with the river Lyd which has already absorbed the waters of the rivers Thrushel and Wolf from beyond Lifton. Downstream stands Lifton Park, or Castle Park as it is sometimes known. The view from the house stretches to beyond the confluence of the Tamar and Lyd to where the Tamar flows down the valley rapidly to Greystone Bridge.

William Arundell Harris built Lifton Park in the Tudor style in 1802. Legend has it that it was intended as a wedding present for his daughter. Harris, however, fell in love with the mansion and kept it for himself. It seems unrecorded exactly what his daughter received instead. Originally, Lifton Park was as a calendar house, having 52 rooms, 365 windows, 12 exterior doors and 7 indoor staircases of which the main staircase had 28 rising treads. With its

Hexworthy House, Lawhitton. During the Civil War, Bennett was a fine soldier and a staunch supporter of the Parliamentary cause. It is believed that at one time Oliver Cromwell lodged at the house.

long façade, believed to be one of the finest in England, it stands amid extensive lawns, gardens and woodland. In 1844, the house came in to the ownership of the Bradshaw family, and they lived there until the 1950s. It was this family who added the Gothic porch and some other Victorian features. During the Second World War, Lifton Park became home to Moffatt's preparatory school, evacuated for six years from Hertfordshire. A commemorative Delabole slate plaque, remembering the school's stay at Lifton Park, was unveiled in Lifton church in July 2002 by Mrs Priscilla Engleheart, widow of Mr John Engleheart who administered the school with his mother during the war. It was the idea of Mr Colin Shaw and others who were pupils at Lifton Park at the time, and have never forgotten Lifton from nearly seventy years ago.

At one time, it became necessary to undertake extensive roof repairs. Sadly, the men employed to undertake the work on that occasion had, unknown to the then occupants, removed all the lead, allowing the rain to penetrate, eventually causing the east wing to collapse and bringing the remainder of the house into a state of disrepair. In 1968, the Dudley Martin family purchased the estate and a programme of restoration was commenced and gradually the house was partially saved. In the 1980s, the mansion was the setting for the BBC television serial *The Hound of the Baskervilles*.

The Tamar sweeps on past Gatherly wood and divides Cornish Lawhitton from Bradstone on the Devon side. Bradstone is discovered through a maze of steep narrow country lanes climbing up from the Tamar. The parish is isolated, there is very little traffic, only the natural country sounds, the gentle clip-clop of horses on the road and the business-like clucking of chickens scratching contentedly round the church door and among the yew trees in the graveyard.

The parish name comes from Saxon times and is believed to mean broad stone. The actual stone, measuring eleven feet by six feet and nine inches thick, is found partly disguised by moss in the hedge, by a field gate, a short distance from the manor house.

The fifteenth-century parish church, dedicated to St Nonna, the mother of St David, has a fine pinnacle-topped tower, and the Norman porch shelters the doorway. Inside there is a barrel roof and a sturdy baptismal font.

Bradstone has not always been as peaceful as it is today. It is recorded that in 1607 there was an affray in the parish church. There were seemingly two main combatants. One was Oliver Cloberry, a peace-loving man from Bradstone Manor. The other was a neighbour, Laomedan Lippincott, who had taken a lease on a dwelling and tenement at Treyeo in the parish. Lippincott, who had a disagreeable nature and delighted in upsetting people, had only been living in Bradstone for a short length of time before he laid claim to some parcels of land

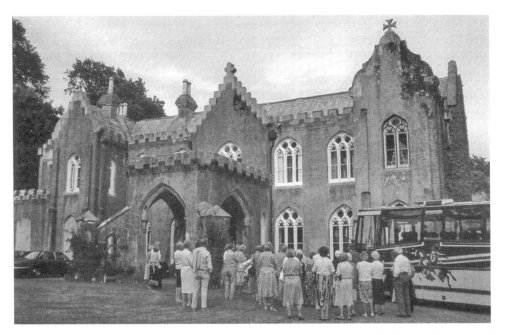

Launceston Old Cornwall Society members enjoying a conducted tour of Lifton Park on one of their Society pilgrimages.

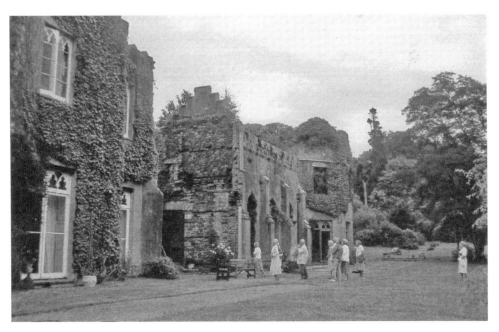

The ruinous part of Lifton Park was draped in creepers and ivy, as this picture shows, and looked like the set for an alfresco production of *Giselle* or a Donizetti opera.

belonging to Cloberry. He also abused Cloberry, his family and servants. One incident occurred when Cloberry and his wife were riding home to Bradstone from Launceston market. When passing Greystone wood they encountered Lippincott who seemed to have been lying in wait for them. Lippincott started railing against the Cloberrys then cocked his gun and threatened to shoot them. The atmosphere was no better one Sunday morning after Lippincott had received Holy Communion. Later in the day he came to the church an hour before evensong still bearing malice against Cloberry and his servants. Lippincott sat himself down in the pew, only large enough for one person and which was usually occupied by Menwenicke, one of Cloberry's servants. When Menwenicke came into church he sat on Lippincott's lap and refused to get off.

As the priest was about to commence the service Lippincott drew a weapon and stabbed Robert Menwenicke three times, twice in the thigh and once in the arm, alarming the congregation. Menwenicke was carried from the church and, to stop any further altercation, Cloberry called for the constable, and shortly afterwards calm was restored. Laomedon Lippincott, after being reproved by the minister and the constable, justified his action. Two other men, William Leamon and Jerman Leamon, acquaintances of Lippincott, were equally antagonistic against Cloberry.

A commission was appointed to look into the case. Lippincott and the two Leomans were sentenced. Apparently Jerman had been seen walking about Bradstone armed with a dagger and a pistol to the consternation of the inhabitants. When Leaman was asked why he carried the weapons, he replied that they were for Cloberrry and his son. He then threatened Cloberry by saying that he knew that he often travelled from Bradstone to Lawhitton along a route on which he could easily despatch him. Strangely, the commission's findings and the outcome and verdict seems not to have been recorded.

There is a curiosity by the church porch, where a remarkable slate stone remembers John Coumbe who, if the inscription is true — and who are we to disbelieve it after all these years — was 120 years old when he died in 1604.

Opposite the church is the Tudor manor house, guarded by its magnificent gatehouse, which has a room above its Tudor arch and six gables, each one surmounted with a pinnacle and finial. Inside there is a short steep staircase, beautiful wooden rafters, a Tudor door and fireplace. Bradstone Manor is first mentioned in the Domesday Book in 1085 when it was held by Baldwin, a Norman sheriff, who also held Okehampton castle. By the middle of the thirteenth century, Bradstone belonged to the de Crues family. Apparently there were three de Crues heiresses, each of whom made good matches by marrying landed gentlemen from the Kelly, Bawcombe and Ashleigh families.

Right: The Tudor gatehouse at Bradstone Manor. Inside there is a spiral staircase leading to the upper chamber where there are Tudor doorways, a fireplace and ceiling timbers.

Below: Bradstone Manor was first recorded in 1085. The present house, built by the Cloberry family, dates from 1601. Since that time it has passed through various families. In a lane by the back of the house, half hidden in a hedge, is the Broadstone which gives the parish its name.

In 1489, after a member of the Bawcombe branch of the family married into the Cloberry family, a third of Bradstone parish passed to that family, in whose ownership it remained for the next 250 years or so. The present house was built in 1601 and, after the Cloberrry family died out, the manor was bought by the Harris-Arundell family of Lifton and has since changed hands several times. At one time, Comte Basil and Countess de Wolovey occupied the manor.

Once, long before there were anti-hunting laws enacted by Parliament, hunt saboteurs had not been heard of and hunting was not a criminal activity. The Cloberry family kept their own pack of stag-hounds in kennels in Bradstone Wood.

The written history of Lawhitton, Landwithon or Languiton, The Fair Town or Fair White Town, stretches back over a thousand years. There has been a church at Lawhitton since Celtic times. In AD 830, King Egbert gave the parish to the Saxon Bishop of Sherborne and then in AD 905 it was transferred to Eadulph, Bishop of Crediton. Later, in 1046, Lawhitton was given to Leofic, first Bishop of Exeter. Then, over a hundred years later in 1153, it came into the hands of William Harlewest, the then bishop of Exeter, who lived at Lawhitton.

The church we see today, dedicated to St Michael and All Angels, is mainly thirteenth century. Its three-stage tower has battlements and stunted pinnacles. Once, the building next to the church was the bishop's palace and proudly displayed a bishop's mitre its the roof. Sadly, the building fell into disrepair and was torn down and has since been rebuilt as a private dwelling. During the nineteenth century, the vicar of Lawhitton, the Reverend Francis de Boulay, built the village school at his own expense. Today, it is the village hall.

At the time of writing, an interesting book throwing light on Lawhitton over eighty years ago has just been found. It is a school geography exercise book, dated May 1927, written and illustrated with diagrams, graphs and water-colour paintings, by nine-year-old Winifred Coombe, a pupil at the village school. In it Winifred writes:

> There is a post office in the higher part of the village, the parish is 2,339 acres (21 water) the population a hundred years ago was about 600 people but now [1927] between 200-300 parishioners. Not so many houses, and no shops. There is a Carpenter's shop and a Blacksmith's shop. There is a working quarry at Carzantic for road metal. There is no policeman living in the village. Occupations are mainly agricultural, cattle, sheep and pig rearing. There is Dairy farming, the milk being sent to the Ambrosia factory at Lifton or used to make butter on the farms.

There are also items on the weather, temperature, flowers and fauna and the geology of the parish.

Eleven-year-old Winifred Coombe, whose school exercise book has recently been discovered, giving fascinating glimpses into Lawhitton as it was in 1927. Incidentally, her dog was called Fly. (Photograph courtesy of Michael and Brenda Hatch)

Lawhitton has expanded, there are more houses, the village shop of more recent years has closed, there is no post office or village policeman. Carzantic quarry closed many years ago, and there is neither a village blacksmith nor a carpenter, but milk is still transported to Lifton. Times have changed since school exercise books were written with a pen and real ink! But village life goes on. At one time, both the Weeks and the Coombe families were contractors who travelled from farm to farm in season with their threshing sets.

Not far from Greystone Bridge, on the edge of Lawhitton parish, is one of the secrets of this corner of Cornwall. Hexworthy House, built of rendered stone under a slate roof, sits amid a wooded landscape a short distance from where the Tamar makes an abrupt change of direction and flows toward Greystone Bridge. The house dates from 1654 but has been extended from an Elizabethan building, or another house of earlier date. At one time, the house was owned by the Bennett family, lords of the manor of Lawhitton. Colonel Robert Bennett was a great supporter of Oliver Cromwell and a fine soldier who served in the Parliament army. In 1646, when the fighting was at its bitterest and fiercest in

A group of well-remembered Lawhitton characters, who used to meet at the village pump on a Sunday morning. This picture shows John Coombe, Andy Gregory, Albert Jenkins, Sid Gilbert and Stanley Barriball. Albert Jenkins was the village barber who on a Sunday morning used to cut his neighbours' hair in his garden shed.

Popular Lawhitton villagers, Fred Wevill, John Coombe, and Alfred Burt, taking a break to pose for the camera, while working on their allotments behind the school.

the area around Launceston, Cromwell stayed at Hexworthy for three days. At the end of the Civil War hostilities, when the Crown Lands were up for sale, Bennett bought Hexworthy. In the eighteenth century, Hexworthy House was remodelled in the Queen Anne style. Bennett died in London and, having no issue, Hexworthy was bequeathed to Edward Prideaux of Padstow.

In March 1984, the northern part of Hexworthy, which had been split into two separate entities in 1945, came onto the property market at an asking price of £67,000 and, according to the estate agent's details, represented excellent value.

Here the river Tamar is literally within the proverbial stone's throw of one of the biggest quarrying operations in the area. At one time, Greystone Quarry was run by Cornwall County Council and then, in the 1960s, was acquired by the Northcott Group of companies. Later, the giant E. E. C. Quarries Limited swallowed it up. Today it is part of the Bardon Group.

Greystone Quarry is massive, the most up-to-date machinery available makes light work of the extraction of the stone, which is used for road hardcore and is transported by fleets of lorries over a vast area of the West Country and beyond.

A rare picture of the Bennett Arms public house, Lawhitton, named in honour of Colonel Bennett of Hexworthy House.

Above Greystone Quarry was Greystone Silver Lead mine or, after a change of name, the Longstone Silver Lead Mine. Until comparatively recently, the gaunt ivy-covered remains of the mine, including the chimney-stack, were clearly visible from high ground on the Devon side. Silver lead was discovered here in 1879 and caused great excitement in the area, particularly as any new undertaking meant new employment opportunities in an already depressed area. The *Launceston Weekly News*, after hearing of the Silver Lead discovery, decided that they would publish what they had discovered.

After describing the discovery of the ore, the newspaper went on to wax somewhat lyrical by praising the nearby hostelry, saying that 'all the wants of man and beast will be catered for in the finest style at the Bennett Arms', which was kept by Mr and Mrs C. Barriball.

Suddenly, the modern-day quarrying operation expanded and threatened the remains of the Greystone Silver Lead mine. Permission was sought to demolish the few remaining buildings and the ivy-clad chimney. Seemingly Cornwall County Council refused to give permission, and a compromise had to be found. Believe it or not, according to Mr Michael Sanders and Mr Francis Hine, who were both employed in connection with the quarry for many years, the buildings and chimney still stand, though they are totally covered by the spoil heaps.

Not so long ago, travellers on the road between Tavistock and Launceston used to try to avoid Greystone around 1 p.m. as they were likely to be stopped some distance away from the quarry entrances for a short while by men standing in the highway waving flags in warning. It was blasting time and there was always the fear that a stray rock might crash on to the highway. Since the quarry workings have moved further away from the road way this is no longer necessary. Today, Greystone Quarry is occasionally open to visitors who are escorted round the complex and can observe the workings from a specially constructed viewing platform.

A little further downstream the Tamar makes a quick change of direction followed by a headlong rush to Greystone Bridge, which stands proud and defiant against all that the force of nature, as well as increasing traffic, can throw against it.

5

OVER GREYSTONE BRIDGE TO BEDFORD COUNTRY

Greystone Bridge is the monarch of all the ancient bridges over the river Tamar, traversing the river where it surges through the steeply wooded landscape. The bridge dates from 1439 and its name is something of a misnomer as it gives the impression that it is actually constructed of grey stone. In fact, the name comes from the old manor of Greyston, which stood nearby.

The eminent Cornish historian Charles Henderson calls Greystone Bridge the fairest bridge in the two shires that it links. Nobody knows for certain who built the bridge. Some authorities say that it was one John Palmer, a well-to-do merchant and M.P. from Launceston, while others favour Thomas Mede, an Abbot of Tavistock. What is certain is that on 27 December 1439 Bishop Lacey granted a forty day indulgence to any penitent who contributed to the upkeep of Greystone Bridge.

The whole structure is 225 feet long, with five semi-circular arches each 23 feet in span and spring posts 10 feet above the water. The great piers measure 27 feet from the river bed to the parapet. There are floodwater arches at either end — 10 and 14 feet in span respectively. The roadway is 10 feet wide. Half the bridge belongs to Devon and the other half to Cornwall.

Mr William 'Bill' Cole vividly remembers as a youngster walking along the parapet of Greystone Bridge high over the Tamar, from Cornwall into Devon and back again. Memory doesn't recall anyone falling into the river.

According to the *Launceston Weekly News*, Greystone Bridge has frequently been a victim to the ravages of modern day traffic. On one occasion, in 1933, a lorry belonging to a Plymouth man was travelling from Tavistock and was suddenly confronted by a car coming from Launceston. The lorry braked sharply to avoid a collision and skidded several yards, striking the side of the bridge, knocking the wall down. The lorry came to rest hanging with its front

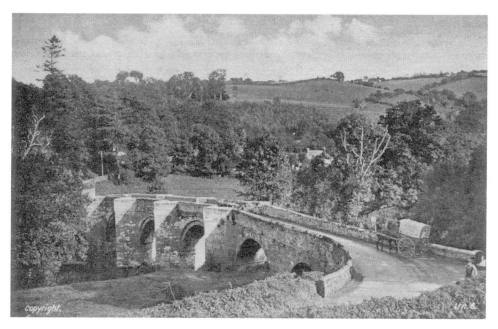

Greystone Bridge, photographed from the Cornish side when horse-drawn traffic was the norm. The granting of indulgences raised enough money to pay for the general upkeep of the bridge. Perhaps this system could be resurrected to help pay for the damage caused to ancient bridges by modern juggernauts.

wheels resting in the field, a drop of several feet. Later, a steam lorry hauled the vehicle back on to the highway. Reportedly, one of the axles was slightly bent and there was considerable damage to the wings but it was eventually able to continue its journey.

In September 1991, a military vehicle struck the bridge. A parapet was damaged, coping stones were torn away and a lengthy section of the side wall was damaged. The bridge was closed to traffic while engineers from the Devon Direct Service bridge division effected the repairs over a two-week period.

Today, Greystone Bridge has traffic lights at either end, but it was not always so and arguments between motorists frequently occurred as to who exactly should have the right of way. Seemingly, being more than halfway over the bridge did not always guarantee right of passage. Several years ago, a situation like this happened. It concerned the night sister from a local hospital, who, after being on duty all night, was driving to her home in Tavistock. Suddenly, when she was well over halfway across the bridge she was confronted by a local farmer and a large piece of farm machinery. He declined to give way, the

nurse refused to reverse back across the length of the bridge and a stalemate resulted. The night nurse explained that she had been on duty all night and that she was going home to bed and that she was happy to sit in her car on the bridge, all day in the sunshine as she was not on duty again that night. She then returned to her car and started to read a nursing journal. The eventual result was inevitable. Night nurse one, farmer nil!

Incidentally, they later became good friends and when on occasion they met on the road they politely acknowledged one another but when they met on the bridge, irrespective of the vehicle being driven, they knew exactly who was going to give way!

Greystone Bridge has its own small claim to fame. It all began in August 1941 when sharp-eyed people in Launceston spotted notices dotted around the town stating that an Ealing Film Unit were coming to the area to make a film on location and inviting people to apply to feature as extras. By all accounts, Greystone Bridge resembles a certain bridge in Brittany. The story of the film centred round the foreman of a factory who travelled to Nazi-occupied France to retrieve a vital piece of equipment and bring it back to England.

The casting directors were Mr and Mrs Ronald Brantford, and among the star studded cast were Tommy Trinder, Constance Cummings, Gordon Jackson,

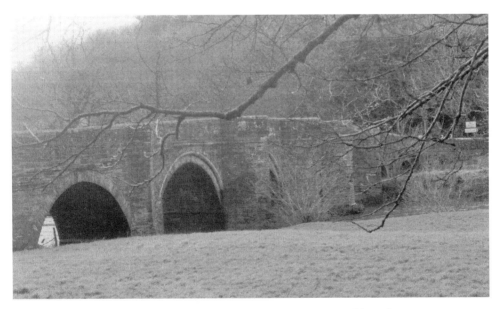

Greystone Bridge was the location for scenes in the 1941 wartime film, *The Foreman Went to France*. Local people who played extras still remember meeting some of the stars and friendships forged then endured until *anno domini* decreed differently.

Clifford Evans, Cicely Courtneidge, who, while on location, all lodged at the White Hart Hotel in Launceston.

Numerous Launceston people applied, as instructed 'at the side door of the White Hart Hotel'. Among the successful local candidates were Mr and Mrs Downing, William (Bill) Adams, Joan Rendell, Christine Negus and Mervyn Copp, who were to play French refugees, so there were no glamorous wigs, costumes or smart uniforms. Everyone had to wear their worst clothes, the more ragged the better. Rates of pay varied according to the skill of the applicants. One was paid the princely sum of £3 per day for which she had to provide her own bicycle. Others were paid £1, another lady was paid an extra 2 shillings and 6 pence (12½ p) per day because she was able to drive a horse and cart.

The cameras began to roll on 1 September for the picture, which was originally called *Portrait of a British Foreman*. The extras were taken by Mr Prout's bus to Greystone Bridge where they were repeatedly drilled in their various parts and actions in a lane adjoining the bridge on the Cornish side. Eventually, despite indifferent weather, the scenes were 'in the can' but the crew were recalled to London due to the expenses rapidly rising above budget.

The film had its West Country premier in Plymouth in July 1942. Several Launceston people who had taken part travelled to Plymouth that night to see themselves and their friends on the silver screen. Locally there was great consternation, particularly in the Greystone Bridge area, as near the end of the film the beloved Greystone Bridge is blown up. The sequence is so realistic that many local people dismissed the clever camera work, use of a model, and cinematic trickery, and were totally convinced that Greystone Bridge really had been demolished

Here Lawhitton and Lezant parishes on the Cornish bank balance Bradstone and Dunterton on the Devon side. Soon the river Tamar separates Cornish Lezant from Devon and then, after a great serpentine loop, is joined at Inny Foot by the river Inny, which has delineated the parish boundary with Stokeclimsland.

One of the finest and oldest houses in the locality is Trecarrell Manor, which Nicholas Pevsner describes as being 'one of the most spectacular buildings of the Middle Ages in Cornwall.' The granite-built great hall, dating from 1500, has magnificent wooden ceiling timbers, two large windows and three smaller ones. Originally the floor was earth and cobbles but over time slate flagstones have been laid. At one time, a screen divided the hall — the inner part was the reserve of the family and the outer part nearest the door was occupied by the servants. Some of the woodcarvings are of a later date and believed to be the work of Miss Trentham of North Petherwin. The hall has been used as a

The exterior of the great hall at Trecarrell Manor, Lezant. The interior has fine ceiling timbers and other wood-carvings, and a slate flagstone floor.

Another pleasing view of Trecarrell Manor and the garden.

dairy and for general agricultural storage and it currently houses a fascinating collection of old farm hand tools.

Legend has it that in the early sixteenth century Sir Henry Trecarrell, having three daughters, Katherine, Jane and Lore, longed for a son and heir. Later he was blessed in this respect but, sadly, tragedy struck in 1511 when the nursemaid who was bathing the infant was suddenly distracted and the child accidentally drowned. Something of a mystery surrounds the tragedy. Some historians state that Lady Trecarrell was stricken with grief and died within a few days. Otho Peter, the esteemed local historian, tells us that Lady Trecarrell and the infant were buried together in the chapel. Both these statements are untrue. No burials or indications of such were found when Nicholas Johnston and the Cornwall Archaeological Group undertook an official dig in the 1980s. In recent years, Mr Burden's research shows that Lady Trecarell lived until 1552 and lies buried under the organ in Lezant church.

The truth is that Sir Henry, obviously distraught, remembered that Launceston Town Council had previously approached him, concerning the rebuilding of the decaying church. He decided to abandon his mansion, which was at an advanced state of construction and which he intended to be the grandest in the district, and to channel his energies and wealth into building the main body of St Mary Magdalene church in Launceston. The tower of the present church dates from the time of Edward the Black Prince.

In the nineteenth century, two small cottages between the tower and Henry Trecarrell's church were purchased by the Duke of Northumberland and torn down. Later, a room for the use of the town mayor was built on the site. This room was in use until 1881 when the guildhall came into use. Today, this same room is the choir vestry.

Over the next thirteen years, most of the elaborately carved granite was brought from Trecarrell to Launceston where it was used to build the main body of the parish church. What makes the church unique are the exterior carvings showing armorial bearings, shields, biblical plants, religious symbols, the recumbent figure of Mary Magdalene and the famous St Mary's Magdalene's Minstrels, forerunners of the church choir. The carved stone portraits of Sir Henry and Lady Trecarrell appear in the tracery of the window next to the church porch.

Ironically, it is Trecarrell's knighthood that is in contention, since documents discovered in Lambeth Palace in 1995 show no record of his being so honoured. Launceston people, however, still firmly believe that Henry Trecarrell was elevated and the lack of a document confirming or refuting his knighthood from Lambeth Palace, or anywhere else, will never change that!

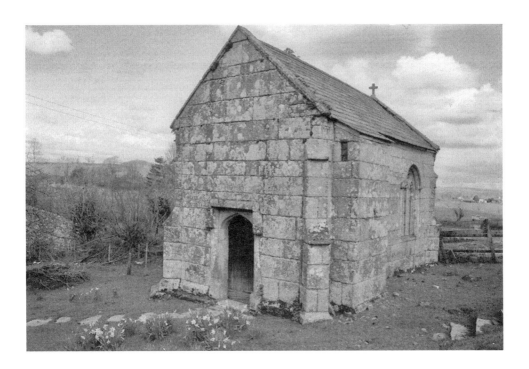

Above: The chapel at Trecarrell Manor built in
1488, which has been sympathetically restored
in recent years.

Right: The private chapel window at
Trecarrell Manor, which cleverly links the
centuries by blending the old with the new.
A modern vehicle features at the base of the
central panel.

Sir Henry Trecarrell died in June 1544 and is believed to have been buried at Lezant though there is no marked grave.

During the English Civil War, Ambrose Manaton, one-time Member of Parliament for Launceston, lived at Trecarrell Manor, a Royalist stronghold which was highly prized by the Parliament forces who attacked it, without success, on two occasions. In August 1644, after crossing the Tamar at Polson Bridge, Charles I and Prince Maurice encamped overnight at Trecarrell with a large number of troops. Next day, the king, at the head of his army, marched off to Liskeard and then to Lostwithiel.

In 1952, Trecarrell Manor was officially registered as an ancient monument. It was extensively restored between 1960 and 1963, and again in the 1980s. Between 1990 and 1994, the massive project of the restoration of Trecarrell Manor was undertaken, during which large mullion windows, part of a long gallery, and a Tudor door, previously hidden from view, were revealed. The sturdy granite-built chapel stands apart from the main buildings. In November 1977, the Grade I listed private chapel, built in 1488 and of special architectural and historic interest, became in need of urgent attention. Originally open to the elements, at this time it was glazed with hand-made glass. Recently, an attractive modern stained glass window has been inserted into the eastern end of the chapel. It bears the inscription 'To the Glory of God in Thanksgiving — Ruth and Neil Burden 2005'. The window has a design which cleverly blends the old and the new and incorporates features of Lezant parish. Surprisingly, but in keeping, a blue Land Rover, complete with number-plate is featured! Apparently the craftsman would have preferred to depict an old wooden farm cart, but Mr Burden, in keeping with the modern theme, decided that a Land Rover would be more fitting as that is the type of vehicle in which he is most often seen driving.

Today, Trecarrell Manor is strictly private property and is the home of the Burden family It is only open to the public on special occasions or by prior appointment, at the discretion of the family.

One of the great cliffs towering above the Tamar at Carthamartha is Bishop's Rock from where there are spectacular views of the river downstream from Greystone Bridge. Carthamartha house was originally on the Bedford Estate and was used as a summer retreat by the family, but was later sold. At one time, the duke had large aviaries nearby where he used to breed budgerigars. It was once a summer retreat for the bishops of Exeter and has also been occupied by Bevan Collier, the artist. Apparently Carthamartha was haunted and the new owners felt uneasy living there, so they had the house demolished and a new bungalow built on the site.

Carthamartha House was once the summer residence of the bishops of Exeter. Later, it became part of the Duke of Bedford's Endsleigh estate. Sadly, the house was demolished and has since been replaced. From near Carthamartha there are magnificent views of the Tamar from the cliffs.

Soon the river Inny makes its contribution to the Tamar and meanders past Wareham Wood and Gunoak Wood. The first parish in the real Bedford Country on the Devon side is Dunterton, first mentioned in the Domesday Book, when it is recorded that Baldwin held the manor of *Dondritona* (Dunterton) and one Ralf de Bruora held it on his behalf. Over the centuries, the manor changed hands several times and eventually came to the Kelly family, in whose ownership it remained until the late nineteenth century.

The parish church, which stands a lone sentinel amid rich agricultural land, is first mentioned in the late thirteenth century. In the mid-fifteenth century it was a chantry chapel connected to the monastery at Tavistock. Later, it became a fully-fledged parish church in its own right. Locally Dunterton church is called 'The Plague church'. Tradition has it that when the Black Death ravaged the area many people living near the church perished. Several children, to escape the horror, and having nowhere else to go, took refuge in the church. The church was renovated in 1891 and it is recorded that Mr Burt from Launceston undertook the work at a cost of around £150.

During the eighteenth century, a colourful character lived in a cave in Dunterton Wood. He was Nicholas Mason, who came, by all accounts, from a respectable family. Mason was a notorious thief who carried out his nefarious deeds in a singular fashion. Late at night he would climb up onto the roofs of the larger properties in the district, lowered himself down the wide chimneys, and stole whatever he could, then made his escape back up the chimney. These mysterious thefts caused considerable consternation in several households in the district when in the morning it was discovered that possessions were missing and there were no signs of a forced entry. Mason's exploits became such a problem that householders were forced to fix iron spikes and hooks in the chimneys to prevent his entry. Seemingly, it all came to a sticky end when Squire Kelly was exercising his hounds who picked up the scent of discarded bones, which led them to a cave and Mason was discovered. Squire Kelly's suspicions were aroused and Mason was later found with a considerable quantity of stolen property in his possession. He tried to escape but was discovered among rocks above the river Tamar. He pulled a pistol and fired at one man but luckily missed his pursuer. He was later arrested and faced trial in Exeter where he was found guilty and hanged.

Milton Abbot, or Middlestone or Middletona as it was once known is dominated by the fifteenth-century St Constantine's parish church, built on the site of an earlier structure. Milton Abbot was once almost entirely self sufficient, there being a handful of pubs, boot makers, cobblers, butchers, blacksmiths, saddlers and a police station. Today, the Edgcumbe Arms is the only hostelry remaining. There is a small shop, The Farmhouse Kitchen, for convenience, incorporating a delicatessen and bakery. The future of the post office is uncertain.

At one time, a focal point in the village was the Bible Christian chapel but this later became a store and was later torn down. In 1835, a new chapel was built on land known as 'Greylands Meadow'. It was opened in July the same year. Several trustees loaned sums of money and in less than twenty years all the monies had been repaid. At the time of writing, April 2009, the old chapel, which has been closed for a number of years, is undergoing extension work and interior remodelling.

The main body of the village school dates from 1839 and was built by the Duke of Bedford, from designs by Sir Edwin Lutyens, as were some houses in the vicinity. Milton Abbot is rightly proud of its drama group, The Milton Abbot Players, who enjoy an enviable reputation for high standards of production. In the early years, plays were staged in the vicarage barn above the stables. Later, when the village hall was built, the Duke of Bedford had a stage installed.

A Milton Abbot Player's production of the Philip King and Anthony Armstrong play *Here We Come Gathering* in 1954. Among the cast is Pat Hillson, John Spear, John Spurr, Jean Vigars, Reg Brown, George Neale, Margaret Dawe (now Dame Margaret Fry).

The cast of the Milton Abbot Player's production of the Esther McCracken play *Quiet Weekend* in 1971. Among the cast is Bill Cole, Barbara Perry, Francis Luke, and Jill Eggins.

According to the players' website they staged their first production way back in the 1920s. During the war years, their name was changed to The Gasbags. Shows were still produced, with the emphasis on variety, making use of whatever local talent was available. After the war, The Players again emerged and have had a continuous line of productions since that time. Originally, all the players lived locally but increased mobility means that they now come from a much wider area. One member, Julie Gale, has graced the London stage, being a regular cast member of *The King and I* at the Theatre Royal, Drury Lane, between 1954 and 1956. Over the years, the players have toured their productions, visiting Launceston, Tavistock and several local villages. All their scenery and props are moved by tractor and trailer.

Endsleigh at Milton Abbot near Tavistock, standing high above the river Tamar, is one of the great Devonshire houses, which the National Trust was not able to purchase because there were difficulties in agreeing a satisfactory financial solution. The 1st Earl of Bedford came into the land hereabouts as the gift of King Henry VIII after the Dissolution of the Monasteries. In the early nineteenth century, the then Duke of Bedford and his family, whose home base was at Woburn Abbey, came to see their 15,000 acre estate for the first time. By all accounts, Georgiana, the Duchess of Bedford, was so smitten by the view up and down the Tamar valley that she resolved to have a house built here as a summer home, and persuaded the duke to agree to her idea. The duchess commissioned Endsleigh (or Iddesleigh as it was once called) from John Wyatt, who was one of the leading architects of the day. Endsleigh was planned so that views of the river were paramount. The 'Cottage', as it was known, was built between 1810 and 1815 of Portland stone and local timber in the Cottage Ornée style and stands on the site of a former farmhouse once occupied by the abbots of Tavistock. The duchess and her four sons, Wriothesley, Edward, Charles Fox and Francis John, laid the first few foundation stones. The house had two main wings containing six reception rooms, fourteen bedrooms, a large service wing, kitchens, and salmon larders. At one time, the majority of Milton Abbot people were employed at Endsleigh in some capacity. There was also staff accommodation. The whole complex is joined together by a curving terrace, which enabled the duchess to watch her young family at play from her study window. In 1816, the family, together with their servants, journeyed for the first time from Woburn Abbey to Endsleigh for an extended shooting, hunting and fishing trip lasting several weeks. The visit became an annual event, usually during May and June, and both the arrival and departure of the party were noted in the local newspapers.

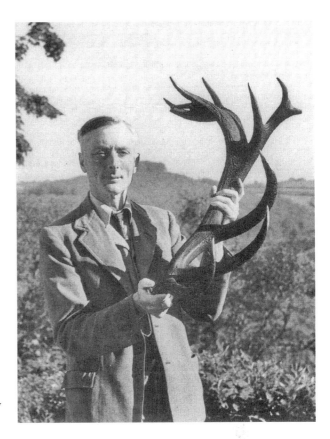

The 12th Duke of Bedford with deer antlers found near Carthamartha. In the background is Castle Head at Dunterton on the Devon side of the Tamar. (Photograph courtesy of Ann and Francis Hine)

Sir Humphry Repton was commissioned to undertake the designs of the extensive 108 acre gardens, which straddle the river Tamar. The grounds are dotted with chalets, grottoes, walks, fountains, pools, cascades and other water features, as well as walks. There are several carriage-ways, known as 'rides' around the extensive woods. Sir Humphry Repton dreamed up a homely touch when he had a cottage built in the woods directly across the river from Endsleigh. Whenever the family were at Endsleigh a fire was lit in the cottage so that a friendly column of smoke issued from the chimney. Apparently the tradition continued until the 1940s. Over the decades, Her Majesty Queen Victoria and many eminent visitors came to Endsleigh and they were lavishly entertained during their stay.

Endsleigh — the dream summer home and estate — served as a holiday getaway for the family for around a hundred years.

In March 1937, Milton Abbot people became concerned for the safety of the seventy-one-year-old Duchess of Bedford, fondly known as 'the flying

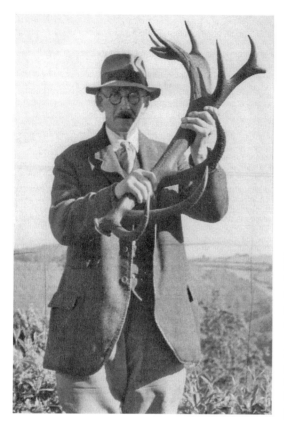

Left: Keeper Alfred Buckingham, whose knowledge of Endsleigh and the estate was invaluable in guiding the party searching for the duke in the right direction. (Photograph courtesy of Ann and Francis Hine)

Below: A glimpse of the deserted main street and the cottages opposite the church in Milton Abbot village. The Edgcumbe Arms is on the right of the picture.

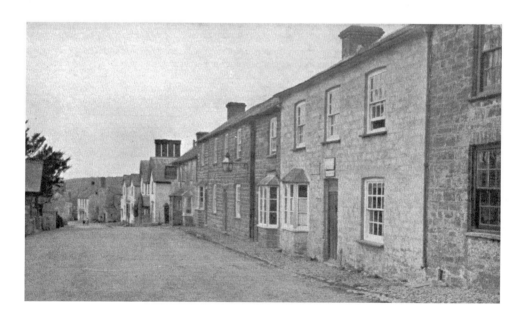

Duchess', who had taken up flying when she was in her sixties. According to the *Launceston Weekly News*, the duchess had seemingly taken off from Woburn Abbey in her Moth aircraft alone for a short sight-seeing flight and had disappeared. The weather was bright and clear and good for flying, though later in the day there had been a snowstorm. When the duchess failed to return to Woburn the police were contacted. Later, hundreds of police, gamekeepers and local people with cars began an extensive search of the countryside around Woburn in a blinding snowstorm. Royal Air Force Planes joined in and extended the search over eight counties. At one period, it was feared that the duchess had crashed into the Fen country or into one of the lakes on the duke's Woburn parkland.

Later, there was a memorial service at Milton Abbot where the church was full with a very large attendance of tenants, employees and old age pensioners. Struts from the duchess' aircraft were later washed ashore at Yarmouth, Garleston, Southwold and Lowestoft, suggesting that her Moth had crashed into the Wash. Older Milton Abbot residents still remember how the duchess used to fly herself from Woburn Abbey to Milton Abbot and land her aircraft on the village cricket field. A conveyance from Endsleigh would be patiently awaiting her arrival in readiness to convey her to the house.

In October 1953, Milton Abbot was alarmed to hear that the 12th duke had suddenly gone missing at Endsleigh. Advice as to where best to concentrate the search was sought from Mr Alfred Buckingham, fondly known as 'Keeper Buckingham', and an extensive search of the estate and the Tamar was instigated, involving troops and frogmen, as well as estate workers. Later, Ernest Masters and William Jordan found the duke's body lying among rhododendrons near the spot indicated. The duke had been accidentally shot while hoping to shoot a hawk which had been preying on his budgerigars. One barrel of the gun had been discharged and the duke had sustained a gunshot wounds to his head. At an inquest in Tavistock, a verdict of accidental death was recorded. To this day, in the minds of the older local people, something of a question mark remains! According to Mrs Ann Hine, granddaughter of keeper Alfred Buckingham, he maintained until his dying day that the tragedy was a terrible and tragic accident.

Endsleigh is noted for its arboretum, numbering over a thousand trees. Large numbers of trees were planted between 1810-1860 and then again between 1910 and 1930. Today, several trees are recognised as Champions in the British Isles.

In 1959, Endsleigh was sold to clear death duties and then, in 1961, Endsleigh, which always enjoyed an enviable reputation for its salmon fishing,

came on to the open market again. It was secured by a local fishing syndicate who were anxious to own the seven miles of prime fishing on either bank of the Tamar between Greystone Bridge and Horse Bridge.

In the 1980s, the Endsleigh Charitable Trust was established to restore the estate. After lengthy negotiations in 2004, Olga Polizzi purchased Endsleigh and the house became a high-class hotel.

A date forever etched on the minds of older residents of South Sydenham or Sydenham Damerel, a long narrow parish squeezed between Milton Abbot and Lamerton, which edges the Tamar a few miles from Tavistock, is 4 January 1955. During the night of that day a freak storm raged and St Mary's parish church was struck by lightning. Mrs Evely, who lived nearby, raised the alarm and alerted the fire brigade and the vicar, Revd A. G. Chappell, as well as the menfolk of the village. Two fire appliances from Tavistock attended, under the direction of Divisional Officer L. F. Orgar and Station Officer J. R. Phillpots. According to contemporary reports, the fire was so fierce that on arrival the fire appliances, having travelled over icy country lanes, found the church to be well alight and the roof fallen into the nave. All the fifteenth-century hand-carved woodwork in the roof, most of it still in its original condition, the altar, pews, and a crucifix were destroyed. The intense heat shattered the medieval window glass and seriously affected much of the granite structure. One fireman, at great risk to himself, did manage to enter the building and was able to rescue some candlesticks and goblets. Ironically, the church tower stood intact and apparently neither the bells nor ropes showed any sign of the overbearing heat. During the interim period, regular services were held in the tiny tower arch. After detailed inspection it was found that complete restoration of the church was not viable. Later, it was proposed that the north aisle should be demolished, to which suggestion the Exeter Diocesan Board agreed. Almost immediately the clearing up work began and, three years afterwards in December 1957, the church was re-dedicated.

The service of dedication began outside the church where the Reverend Chappell asked the bishop to perform the ceremony. The architect, Mr D. H. Parsons, handed the key to the bishop who moved in procession to the chancel. Clergy from several neighbouring parishes took part. Celebrations were signalled by the tolling of the church bell, which rang out from Sydenham Damerell in this quiet corner of the Devonshire countryside and across the Tamar into Cornwall. Today the church can accommodate around forty worshippers.

Here the Tamar is swift flowing but seems hemmed in by trees as it forces its course through lush meadows on its way to Horse Bridge.

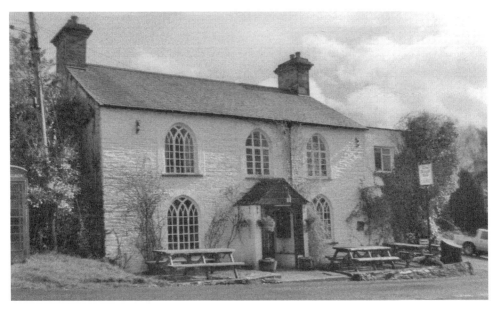

The Royal Inn at Horse Bridge, which was once a monastery. It was given its name after Charles I lodged there. It is now one of the more popular hostelries in the area.

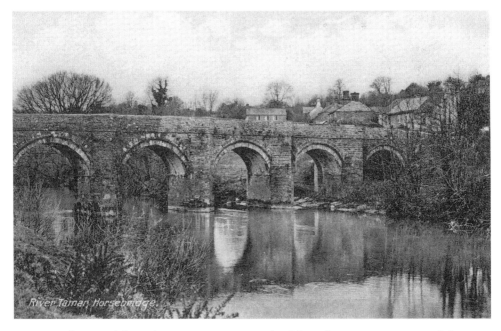

Horse Bridge, straddling the river Tamar since the fifteenth century, was one of the more important river crossings, but, alas, no more! Other routes and other bridges take the strain. (Photograph Gerald Fry collection)

Lamerton village stands back from the Launceston to Tavistock road and is surprising. There are several quaint cottages, a thirteenth-century priest's house, restored in 1934, and a fifteenth-century parish church. Inside, dominating an aisle, is the huge memorial to the Tremayne family. A window remembers two churchwardens who served the church during a traumatic period in its history. Thomas Roskilly and James Ellis both held office while the church was undergoing restoration in 1876, at the time of the fire in the following year and also during the subsequent period of rebuilding. A slate tombstone in the churchyard commemorates Elizabeth Williams who died when she was aged one hundred and eleven years (carved in full). Seemingly, the stone mason, Mr Parsons of Launceston, was somewhat sceptical as the age is followed by two exclamation marks. Sadly, the date of death has weathered away.

Once, Horse Bridge, probably one of the lesser-known Tamar crossings, carried the main road between Tavistock and Liskeard. This magnificent bridge, some fourteen miles downstream from Greystone, dates from 1478 and is similar in appearance to that bridge. In 1437, Bishop Lacy granted an indulgence to *Hautes Brygge*. The bridge has 6 semi-circular arches each 20 feet in span and 17 feet high. The water is 5 feet deep and the central piers 30 feet from the bed of the river to the parapet. The roadway is 12 feet wide. There is, however, one curious difference. A set of strange stone brackets, an integral part of the structure, can be seen near the top of the cut-waters on the upstream side. It is believed that these were used to support wooden poles, which in turn held fishing nets.

Nearby is the historic fifteenth-century Royal Inn, once known as the Packhorse, on an old drovers route. According to legend, the Royal was originally a nunnery whose foundation was closed down on the express command of Charles II. This theory is strongly supported by the locals who indicate as indisputable proof a crown carved in the front doorstep.

From Horsebridge the Tamar rushes through the valley for some distance under Kit Hill and on through the mining country toward Gunnislake.

6

HORSEBRIDGE BY KIT HILL TO GUNNISLAKE

The part of the river Tamar borderland around Horse Bridge is of singular interest. One of the earliest references to Stokeclimsland, separated from Lezant by the river Inny before it joins the Tamar at Inny Foot, comes from the time of the Domesday Book. In 1856, Kelly's directory describes Stokeclimsland as a mining district.

Stokeclimsland's fifteenth-century parish church has a three-stage tower, built in the Perpendicular style, topped by battlements and pinnacles. There are eight bells, cast by the Pennington family, bell-founders who lived in the parish. By 1790, the bells were untunable and the following year they were recast and they were recast again in 1952. The church has an unusual holy water stoup, a fifteenth-century barrel roof with interesting carved wooden bosses, an owl and green men among them. The altar stone is cut from Kit Hill granite and was installed by Canon Andrews in 1928.

Stokeclimsland post office is believed to have been opened in direct response to demand from the Call Family of nearby Whiteford Manor, to accommodate the mail generated by the mines in the district. Interestingly, this particular post office is one of the oldest such establishments in the country, having opened for business in January 1839. It has always operated from the same building from where it operates today. The first postmaster was a Mr Crafter, then later by the Stumbles family.

The Reverend Martin Andrews, later Canon, is synonymous with Stokeclimsland. He was appointed to the parish in 1922 and remained there for the next forty-eight years. When the Duke of Windsor visited Stokeclimsland in 1933 he discussed with Canon Andrews the high unemployment in the area and an allotment scheme was mentioned. Soon afterwards, Canon Andrews launched his own scheme at Stokeclimsland because so many ex-service men

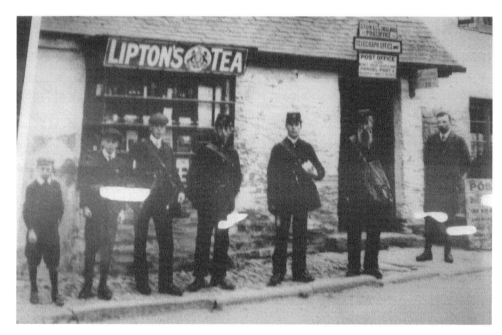

Stokeclimsland post office, which has a fascinating history. The first postmaster was Mr Crafter. This picture shows Mr Stumbles the postmaster and post office staff, looking as if they are about to start deliveries over a hundred years ago.

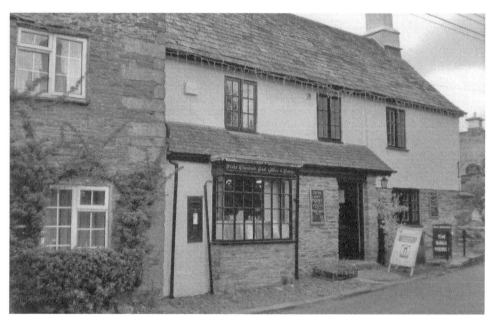

The post office and village shop, a virtual emporium stocking a huge range of goods, at Stokeclimsland as it is today.

were unemployed. The canon's scheme was based initially on the rectory garden and then enlarged by several acres, rented from the Duchy of Cornwall estate. The scheme quickly became a success and over forty men were involved in growing vegetables, fruit, flowers, rearing pigs and poultry. The produce was sent to markets in Manchester, Birmingham and London, while a certain amount was sold in Plymouth and other local markets. In 1936, the Duke of Windsor, now as Edward VIII, visited Stokeclimsland and he remembered the allotment scheme and enquired how it was progressing. The scheme was finally wound up in 1967.

Len Harvey, who became a boxing champion, was born at Polhilsa, Stokeclimsland, in July 1907. His early training took place at the Cosmopolitan Gymnasium at Devonport. Interestingly, Harvey had his first fight, billed as a paperweight contest, which he won when he was only twelve years old. He was known as the gentleman of the ring, won three Lonsdale belts and in 1939 he became Light Heavyweight champion of the world. In 1942, Len retired from boxing to become a publican in London and died in November 1976.

Polhilsa House has a secret history, which until a few years ago lay hidden. The house was requisitioned during the Second World War and became the secret headquarters of a clandestine army, the idea of Winston Churchill. Men with specific local knowledge were trained in resistance and sabotage techniques to put into operation should a German invasion take place. The work of these auxiliary units was highly secret and members were poised to swing into action. Polhilsa House returned to private ownership soon after the war.

Stokeclimsland has long enjoyed strong royal connections. In the late 1800s, due to mounting debts and the dismantling of the Call estates, the Prince of Wales, Duke of Cornwall, who bought the Whiteford estate, became a greater presence in the area. The Duchy Home Farm was established at Stokeclimsland in 1913. Seventy years or so later, in 1984, this was to become the basis of the Duchy Agricultural College. At this time, it was the only new Agricultural College established in the country for around thirty years. His Royal Highness, Prince Charles, Duke of Cornwall, formally opened the college in November 1986. The college occupies 450 acres of land leased from Prince Charles, Duke of Cornwall. The building complex, having been designed to sit comfortably in the surrounding landscape, comprises new residential quarters for some forty students. Old agricultural buildings have been converted into classrooms, computer rooms, an extensive library and laboratories. It offers students a wide choice of practical and academic courses, with the aim of giving students a sound grounding in modern farming methods and up-to-date farm management

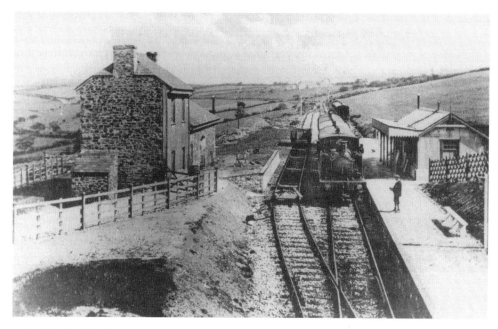

Stokeclimsland railway station (once known as Monks Park Station). After complaints by a local clergyman, the Reverend Walters, its name was changed to Luckett Station. The railway itself fell victim to Dr Beeching's axe. (Photograph Colin Barrett collection.)

skills. There is also a herd of cows, sheep and an equestrian centre. Successful students gain the National Certificate in Agriculture.

Below Stokeclimsland the tree-lined Tamar turns its back on Horse Bridge and heads south toward mining country.

Holmbush, at Kelly Bray, where copper, lead, tin and arsenic was mined since the eighteenth century, was one of the most productive in the area. By 1835, the main shaft of Holmbush mine was 600 fathoms deep and in 1840 around 200 men and boys were employed. Later, the Redmoor, Kelly Bray and Holmbush mines were all known as Callington Mining Company, which concern collapsed in 1854. Mining finally ended here in the middle of the twentieth century.

Kelly Bray has undergone big changes in recent years. Older residents recall several shops, Dingle's sawmill, the Glover and Uglow Haulier's depot, the railway station, all of which have vanished, to be replaced by modern housing development.

No one knows exactly how Killiwick, or Calweton, two of the old names, evolved into the present Callington but the town has a long and interesting history. Callington was granted its first charter by Henry III in 1267, when

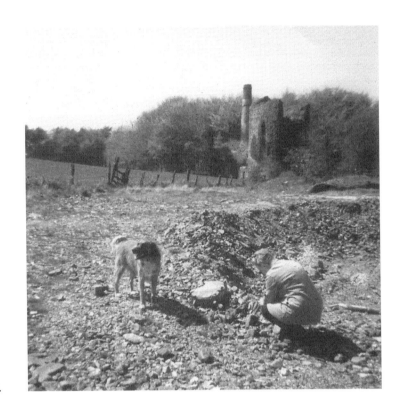

Holmbush Mine at Kelly Bray was once a magnet for those interested in collecting minerals.

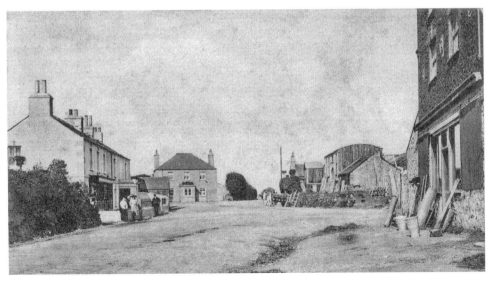

Kelly Bray, a mile from Callington, as it was in 1905. The village came into existence because of the railway terminus being here and not in Callington. It is probably one of the most changed places in the river Tamar borderland.

A busy summer's day in Callington during the 1920s. The motor vehicle probably caused some interest but hopefully it did not frighten the horses.

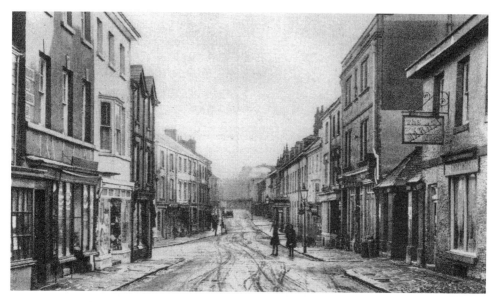

Fore Street, Callington, under snow, showing the Market House Inn, once known as The Three Cranes. Over time, Dymond's bicycle shop, Cornish's grocery shop, Pomeroy footwear and the Plymouth Co-op were among the thriving businesses located in this street.

permission was given to hold a weekly market and an annual fair. The parish church, dedicated to St Mary the Blessed Virgin, was built in 1438 from large rough blocks of Kit Hill granite on the site of a much older church. Originally South Hill was the mother church of Callington. The tower, which rises to 67 feet, has corner buttresses and pinnacles. The double north aisle was added in 1882. There are four wide bays with square piers, half shaft and arches. There is a clerestory, with windows over the spandrels. The south door and the wagon roof are original. Inside there are numerous features of interest. There are two side chapels, dedicated to St Nicholas and St Andrew, a Romanesque-style Norman font, with faces and rosettes in circles, the royal coat of arms of George III, dated 1811, a pulpit dating from 1906, stained-glass windows, brass and slate memorials. There is a brass to Nicholas Aysshton, an eminent judge in the mid-fifteenth century and a benefactor of the church. Sir Robert Willoughby de Broke, who died in 1502, and his wife are commemorated by a large alabaster monument. In the sixteenth century, Willoughby was an eminent judge and steward to the Duchy of Cornwall.

Due to its strategic position between the Tamar and the Lynher, Callington has over the centuries developed into a largely agricultural centre, which gave way to mining, but when mining hit a slump in the nineteenth century, followed by a mass exodus of emigrating miners, agriculture flourished again.

A red-letter day in the Callington social calendar falls in October — Honey Fair Day. In 1880 it was reported that honey was 2 shillings and 6 pence (12½p) per quart! Apparently there was an unusually large attendance, with numerous peep shows, swing boats, shooting galleries, cheap-jacks, and that large numbers of the unwary were fleeced of their money. There was a large amount of farm stock for sale, including pigs, cows, calves and sheep, and Mr W. H. Roberts held his first monthly sale of Fat Stock. Honey Fair lapsed but was revived in 1978 by a Callington man, John Trevithick. Since that time, Honey Fair has flourished and in recent years has been organised by the Callington Lions Club.

The celebrated murals on buildings around the town are unlikely tourist attractions. One shows the return of King Arthur, another depicts the Tamar valley and bee hives, a third milk churns with Kit Hill stack on the horizon. Another depicts an old car, while another shows a railway locomotive. What must be everyone's favourite is called The Secret Pasty Factory showing the pasty-making process in a fictitious factory. The newest mural, in the town centre bus shelter, was designed and painted by young Eleanor Gosney in 2006. It shows thatched native huts in Mwakashanhala, an African village, with which Callington primary school is twinned.

Callington has several murals dotted around the town. This picture shows The Secret Pasty Factory and is particularly amusing for visitors and shoppers alike. All the murals have become attractions.

In January 2000, a film crew came to Callington to shoot scenes for a film called *Conspiracy of Silence* whose story revolves round the Catholic Church and a wayward priest. The film stars Brenda Fricker, Jonathan Forbes, Hugh Bonneville and Hugh Quarshie. Members of 'Prim Raf', the Callington drama group, and several local people played extras in most scenes. Prior to filming Callington was transformed into Irish — *Galeranagh*. Street names were changed, shop frontages altered, car number plates became Irish ones, letterboxes were painted green. The Old Clink became 'Molloy's' and the Bulls Head was changed to 'O'Grady's'. To give the picture a more authentic look, mud was dumped in the streets.

Kit Hill, overlooking Callington, is unique. It gives visitors expansive views in every direction, to Bodmin Moor, to Cornwall's china clay district, to the Cornwall's northernmost corner, to Dartmoor and to the Tamar valley as the river threads its way toward Plymouth.

There are varying thoughts as to how Kit Hill came by its name. Some sources believe that it was named after a man called Kit who was murdered while in charge of the miner's wages. Other scholars favour the Danish *Tau Maur*, meaning tidal water. Rising 1,091 feet above sea level and extending to around 400 acres, the hill oozes a singular atmosphere linking the distant past and the present.

Around the summit area archaeological remains are abundant; Bronze-Age barrows, axe heads and worked flints have been found as well as weapons and ancient burial chambers.

Every seven years or so during the twelfth and thirteenth centuries, both the Devonshire and Cornish tinners held their parliament on the hill, at which occasions all the newly-formulated Stannary laws were ratified and disputes settled. Over the centuries, extensive mining for copper, tin, lead, wolfram and arsenic have all taken place on Kit Hill, which was the centre of mining and quarry hereabouts.

Once, the summit of Kit Hill was topped by a windmill, affectionately known as 'Doctor's Folly', which was used to provide the power for pumping water up from the mine below. The windmill fell victim to a savage storm and was wrecked. Legend has it that a small boy, who was attending the windmill at the time, was blown away and was eventually found in Saltash! Since 1885, the hill has been crowned by an 85-feet tall mine chimney. Its pedestal base and ornamental coping stone top was insisted upon by the Duchy of Cornwall, as the structure is a landmark for miles around. Today, the original beauty of Kit Hill stack is somewhat marred by the proliferation of communication aerials.

At one period in the nineteenth century, it was planned that two tunnels, one from Silver Valley at Fullaford, the other from the small Excelsior mine working begun in 1877. Its entrance is located in Deer Park Wood, between Downgate and Luckett. The project proposed that the tunnels should meet under the main shaft of Kit Hill mine. The tunnels would be used for moving ore and rubble as well as drainage. Apparently difficult working conditions, due to the hardness of the granite, and prohibitive costs swamped the idea and the Silver Valley tunnel was abandoned. Several attempts to extend the Excelsior tunnel were made in later years but the excavations were aborted in 1938.

The mines and quarry operations always worked in close proximity on the hill. When the mines became successful it was soon apparent that some

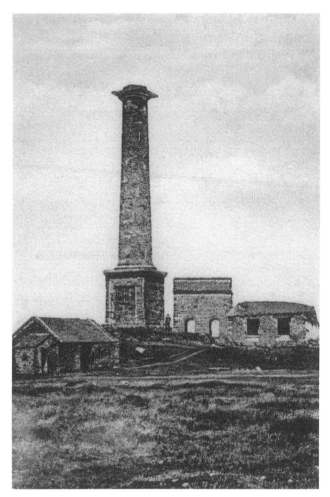

Kit Hill Mine stack with its ornamental top, pictured before the surrounding mine buildings were demolished. The summit stack is a landmark for many miles. On a clear day it is possible to see the dish aerials at Morwenstow near the Tamar's source and Devonport and Plymouth.

quicker form of transport was necessary to move the ore and granite down to Calstock and the other Tamar ports for shipment. This provided the impetus to build a small narrow-gauge mineral railway up to the foot of Kit Hill to service both the mines and quarries. Originally the line was called the Tamar, Callington and Kit Hill Railway. In 1864, just before it began its working life, it became the East Cornwall Mineral Railway, which opened for traffic in May 1872. The first mile or so from Calstock was a cable worked incline and there were sidings at Greenhills and Clitters and at the foot of Kit Hill. Two saddle tank steam locomotives were worked over the eight miles to Kelly Bray, which became a thriving terminus. In 1891, the railway was taken over by the Plymouth, Devonport and South Western Junction Railway. The new owners

had already opened a standard gauge line from Bere Alston to Devonport. In 1905, a viaduct was built to cross the Tamar at Calstock. A wagon lift was constructed and the new line opened for business in 1908. Kelly Bray station opened in March 1908, later to become known as Callington Road and then Callington. Since then, various schemes have been launched for a new line directly into Callington from Lydford, another proposal planned a line to Camelford, Tintagel and Boscastle but none came to fruition.

Over the years, the line had several changes of management. It was run by Southern Railway, then British Rail Southern Region followed by British Rail Western Region after which the line was left to fall into decline. The death-blow for the line was struck when the Beeching report was announced. Understandably, a great hue and cry ensued from the fruit, vegetable and flower growers in the Tamar valley, who were most affected as they were expected to take their produce to the main line. Fortunately, the line to Gunnislake was saved but there was no reprieve for the stretch to Kelly Bray, which closed in November 1966.

During the First World War, the Duchy of Cornwall opened a wolfram mine on Kit Hill as part of their war effort. Wolfram was used in the hardening of steel and, according to the information board on Kit Hill, by 1918 there were a hundred men working underground and seventy more at surface level. The Duke of Cornwall visited the site after the war ended, and the mine closed down in 1921. Today, the entrance to the mine is still visible by following a path from the car park, situated halfway up the hill.

Kit Hill mine began working for copper and tin in 1858. A few years later, the shaft was 350 feet deep, Kit Hill Great Consols mine began working, and confidence in the new venture knew no bounds. New tunnels were dug and shafts deepened. The mine finally closed in the late nineteenth century. In the early twentieth century, the engine houses disappeared from the scene and then, in 1928, the same year as the road access to the summit was improved, the remaining buildings were torn down. The chimney stack of the South Kit Hill mine still overlooks the southern slopes, but the range of accompanying buildings were torn down in the 1980s.

Due to its high quality, Kit Hill granite was world famous and shipped overseas in vast quantities from the Tamar ports. In their heyday, several hundred men were employed in the Kit Hill quarries. An incline plane was used to lower the laden trucks down to the mineral railway and sidings at the foot of the hill, from where it was taken to Calstock for shipment. Today the incline is a long steep grassy slope. Over time, the workings were gradually scaled down and the granite quarrying operations ceased in the 1950s. To this

day, partially-worked granites lie near the entrance to the main quarry, some bearing the feather and tare splitting marks.

A Midsummer Eve custom was started in 1929, when a chain of bonfires, stretching the length of Cornwall, was lit on all the highpoints from Lands End to Kit Hill. Currently, the Kit Hill bonfire ceremony, which several hundred people attend due to its strategic position overlooking the county borderland, is one of the most important links in the chain and is the responsibility of Callington Old Cornwall Society together with other local organisations.

During the Second World War, three bronze plaques, which had been placed on the summit, giving visitors information as to the direction and distance of certain places, were removed into safe custody as they may have been helpful to enemy parachutists.

Kit Hill hit the headlines in the late 1950s. Rumours were rife in the district that something strange was happening at the hill. A discovery in the 1980s revealed that in the late 1950s the Atomic Energy Authority undertook highly secretive seismic tests in small specially excavated chambers deep inside some of the old mine workings. It seems that a highly sophisticated listening post was established, capable of detecting underground explosions in the English Channel, registering their subsequent shock waves and differentiating between them and earthquakes.

In 1985, to mark the birth of Prince William, HRH Prince Charles, Duke of Cornwall, gave Kit Hill to the then Cornwall County Council. The prince stipulated that Kit Hill should be a low key country park with special emphasis on educational and recreational activities for young people. Today, in addition to walking, horse-riding on designated paths, the flying of model aircraft, kites and nature study, there are courses for young archaeologists. More adventurous activities like rock climbing and canoeing are undertaken, together with life-saving techniques, which are strictly supervised by qualified instructors from the Delaware Centre.

As the land drops away from Kit Hill towards the Tamar it is punctuated with old mine chimneys and engine houses, all stark reminders of a once-thriving mining industry round Harrowbarrow, Metherell, Chilsworthy, Gunnislake and Calstock. From earliest times, the mines round Luckett, Wheals Martha, Sheba, Josiah and Benny were the life-blood of the village and as such are all still remembered. In its time, Luckett New Consols mine, originally started in the mid-eighteenth century, became recognised as one of the most prolific producers of tin in the area. The Duchy of Cornwall owned the mineral rights. It is recorded that in 1875 Luckett New Consols mine produced between eight and nine thousand ounces of silver. In 1878, due to a slump in the price of

Kit Hill is a centre for numerous leisure activities, including walking, horse-riding, bird watching, canoeing or, as shown in this picture, climbers scaling one of the sheer rock faces in the quarry.

minerals, the mine became uneconomic and closed. During the First World War, the waste dumps of the previous workings were reworked and several tons of black tin and arsenic was recovered. After having lain derelict for around seventy years, interest in the mine was rekindled in the 1940s when explorations by a private enterprise took place and revealed tin, copper, silver, wolfram and arsenic. With a view to re-opening the mine, a lengthy pumping operation was undertaken and rotten timbers were replaced. In 1949, when the mine reopened and moved toward full production, a hundred men were employed and it was expected to recover and process 30,000 tons of ore

A corner of Luckett, once the centre of a rich mining area. Evidence of the village's mining heritage remains.

annually. In December 1952, mining at Luckett came to an end and around seventy miners were made redundant.

The soaring chimney, with walls 4 feet thick, built of local stone and brick, and the buildings remained a monument to Luckett's mining heritage until they fell victim to development in March 1968. When it came to demolishing the chimney, forty-one Commando Royal Marines from Bickleigh, Plymouth, were approached. The Marines seized the opportunity to use it as an exercise, and a ten-man strong assault team demolished the chimney.

As recently as July 2009, Broadgate engine house, an 1870 Grade II listed building, came up for auction and offered, to quote the estate agent, 'a chance to own a part of history' but the property was withdrawn at the last minute.

After passing Luckett the Tamar makes a great loop and turns back on itself to head towards Latchley.

Latchley weir was built in 1849 to dam the river in order to keep the water level high enough to allow a strong flow of water to be diverted into what was called the Great Leat, which carried water over two miles to the Devon Great

Consolidated Mine, where it worked waterwheels. The weir was partially blown up in the 1920s and today its remains are known as the rapids.

The railway came to Latchley in March 1908. One lady who, according to the *Launceston Weekly News*, had a singular connection with the line was Mrs Sarah Jane Jenkyn, who was born at Downgate in the Tamar valley and spent all her life within the sound of the river. Mrs Jenkyn taught generations of schoolchildren in both Gunnislake and Latchley schools. Later, Mrs Jenkyn became station mistress at Latchley; at one time, she was the first and only station mistress in the country. She died in 1981.

The Tamar glides by Lamerhooe and Blanchdownwood on the Devon bank.

It was the discovery of copper in Blanchdown plantation in 1844 and the creation of Devon Great Consols Mine that would make the Tamar valley mining scene legendary the world over. In the nineteenth century the Williams family pleaded with the 6th Duke of Bedford to be allowed to re-open Gunnislake Old Mine but he rejected the proposal, as the area had already been developed into a game bird enclosure. Later, the 7th Duke of Bedford was more amenable to the idea, as he could clearly see the possibilities. In March 1844, Josiah Hugo Hitchens secured the duke's permission to re-open the old workings for a period of twenty-one years. The duke, however, was an astute man to deal with and he negotiated a royalty on the tonnage of ore raised.

New Bedford Mines, or Wheal Maria after Hitchen's wife, and the shaft became known as Gard Shaft after Richard Gard M.P. for Exeter who held a number of shares in the enterprise. A memorable day was 4 November 1844. A copper lode was struck and, by the end of the day, a quantity of valuable ore had been raised.

A second working was established — Wheal Fanny, then Wheal Maria, Wheal Josiah and Wheal Emma. In 1846, the group of mines became known as the Devon Great Consolidated Copper Mining Company. The mine eventually covered 140 acres, with thirty or so shafts and forty miles of levels, some being 1,500 feet deep passing under the Tamar. It is said that it was possible for a miner to walk the 2½ miles from one end of the working to the other and never come to the surface. Soon the mine became so profitable that the shares in the enterprise, on offer for £1 each when the scheme was first mooted and initially difficult to sell, were now readily changing hands at £800 each.

The mine flourished, and in the first year over 13,250 tons of ore was raised. During its lifespan the mine's output was in the region of 750,000 tons. Originally, strings of horses drew carts laden with ore from the mine to Morwellham Quay. Later, a five-mile long rail line was laid, after which locomotives hauled trains often up to fifty wagons in length. By 1858, the mine

was by far the biggest employer in the area, drawing workers, including women, boys and girls, from a wide area. A score of captains supervised over 450 men and boys. There were 140 men, over 200 women and nearly 170 boys.

By the 1860s, early signs indicated that the copper was beginning to run out, but around that time arsenical ores came into their own. The ore was smashed into small pieces and roasted in calciners. The white crystal powder was transferred via a chute into paper-lined barrels and taken by horse and cart, later by train, to the Tamar ports. At one time, over a hundred people were employed here in the long hazardous process, producing several hundred tons of arsenic weekly.

Arsenic has many uses, in particular in insecticides, paint, glass, enamel, cosmetics, wallpaper and medicines. At one time, vast quantities of arsenic were shipped to America where it was used as an insecticide to eradicate boll weevil, which was destroying the cotton crop.

A decline later set in and in 1881 the weather, too, conspired to make matters more difficult. The Tamar froze, stopping all the waterwheels from working which, in turn, affected production and ultimately sales. At the end of November 1901, all work ceased apart from the necessary pumping to control the water level. In all, some 350 employees were affected. Two years later, in 1903, the mine materials were sold off, the shafts filled in and most of the buildings levelled. After fifty-five years, one of the greatest copper mines in Europe came to what may well have been its end. Spasmodic working continued, supported by the Duke of Bedford. During the last war, quantities of ochre were obtained for paint manufacture. For nearly a quarter of a century Devon Great Consols Mine was the greatest copper discovery in the South West and became the richest copper mine in the country.

Straddling the Calstock to Chilsworthy road the Greenhill Arsenic and Precipitation Works with its chimney well over 200 feet in height was an eye-catcher all over the Tamar valley. In 1875, the Cornwall Chemical Company established the arsenic works on the site. It was in two sections and an incline joined the two by crossing over the Gunnislake to Chilsworthy road, via a bridge. The East Cornwall Railway was also connected to the works. The main flue from the chambers of the chemical works, after passing under the highway, emerged in the brick works and went above ground to the chimney. The works had its own cooperage where several hundred casks were made weekly. According to some accounts, Greenhill works had mixed fortunes. In July 1876, it started to ease off production, but continued operating for a few years though on a much reduced scale. In 1891, the works was taken over by the Callington United Mines company. Greenhill ceased operating in the early 1920s.

Soon the Tamar passes through its deep tree-clad ravine and the cliffs of Morwell Rocks on the Devon side come into view and shortly Gunnislake and New Bridge where the Tamar becomes tidal.

7

GUNNISLAKE, MORWELLHAM, CALSTOCK AND COTEHELE

Once Gunnislake was just a random collection of houses by the river Tamar. Its name is believed to have come from *gunnis*, the Cornish for 'old mine with a lake'. In the fifteenth century, New Bridge was built by Piers Edgcumbe of nearby Cotehele. It measures 182 feet, its 6 slightly pointed arches spanning the river, each standing 23 feet over the water, carrying a single file roadway. The significance of New Bridge is immeasurable. Some scholars regard New Bridge, once the nearest border bridge crossing to Plymouth, the finest on the Tamar. It was certainly one of the greatest crossings over the Tamar until the Royal Albert Railway Bridge was built in 1859. In 1961, the Tamar Road Bridge became the principal crossing point.

During the Civil War, both the Roundhead and Royalist forces recognised the strategic importance of the bridge, and a fierce skirmish ensued, during which over 200 soldiers were killed.

The chief source of employment in the area were local quarries supplying great quantities of granite for use in construction projects, among them the massive fortifications round Plymouth. Following the discovery of rich lodes of mineral ore in the district during the nineteenth century, rapid change came to Gunnislake. Hundreds of miners came seeking work and the village quickly expanded. Rows of small cottages were built to house the miners and their families, churches, chapels and public houses sprang up and the valley reverberated with the constant beat of industry. Today, the cottages are being given new leases of life as holiday lets, second homes or dormitories for the workers who daily commute to Plymouth and other towns.

Gunnislake seems to have lost much over the decades. The mining and quarrying operations have ended, and both the brickworks at Bealswoood and the bone crushing mill have gone.

New Bridge, Gunnislake, was once the nearest point to Plymouth at which the river could be crossed.

The Caledonia was built on the Cornish end of the bridge in 1802, as a three-storey granary to serve the Tamar Manure Navigation Canal. Later its height was raised and it became a paper mill then a brewery and afterwards a combined miners' lodging and ale-house, whose reputation was legendary. The Caledonia was demolished in the 1920s and a motor vehicle garage now occupies the site. The building is depicted in Joseph Turner's famous landscape, *Crossing the Brook*. Today, there is a Turner Centre here and a trail which visitors can follow.

In 1994, the railway bridge, which had straddled the road since 1872, was removed to allow access for large, vehicles into the village. The railway station was relocated to the opposite side of the road.

Tin was mined at Drakewalls from earliest times, firstly from large pits on the surface and then underground. Over the years it was to become one of the most famous tin mines in the Tamar valley. In the eighteenth century, shafts were sunk and potentially more profitable lodes were found, and consequently the workings were deepened to around 1,300 feet. Drainage of the mine was always a problem and waterwheels for pumping were installed

in the early nineteenth century. By the latter part of the nineteenth century, around 350 people were employed but in 1873 mining operations faltered. However, a new company took over the mine, new equipment was installed, and work restarted. A few years later, in 1881, a new management structure was put in place and with it came a new name, Drakewalls United. Disaster struck Drakewalls Mine in February 1889. Four miners, William Bant, William Tucker, John Rule and Henry Davis, descended to the forty-fathom level to work their morning ore. Suddenly there was a great roar, followed by a run of ground (a sudden tunnel collapse within the mine workings). Davis and Tucker fell through into another part of the mine. Bunt and Rule, both married men, were buried. News of the accident spread and soon a thousand people had gathered at the mine. The engine shaft was roped off and the police had to enforce order. Shortly afterwards it was discovered that there were no accurate maps of the disaster area which delayed any rescue attempt. Fortunately, a miner, called Collins, who had previously worked in the part of the mine where the accident happened, was located working at the Prince of Wales mine at Harrowbarrow. Collin's knowledge of Drakewalls Mine was invaluable and it was decided to attempt a rescue mission through new ground. A second rescue team would try to reach the pair from the forty-fathom level. In total, about forty miners were involved in the rescue bid. After four days, the rescuers reached the trapped pair who were found alive and uninjured.

The first rescued was Rule followed by Bant, who were examined in the engine house by surgeons Wood and Bowhay. Later, both men were conveyed to their respective homes at St Anne's Chapel and Harrowbarrow. Over a thousand people attended an open-air thanksgiving service at Albaston.

In the 1860s, the tribute system, which unfairly fixed the price of ore, was widespread and caused unrest among the miners. In an effort to end the practice the Miners Mutual Benefit Association was formed. Not surprisingly the miners and management clashed. Union members were locked out of Drakewalls Mine, and it all boiled over in February 1866, when a blackleg worker was jumped when he came off shift. He was lashed to a pole and carried with much shouting and jeering through the streets of Gunnislake. The manager of Drakewalls Mine, Captain Gregory, armed himself with a knife and called the police. Several miners were arrested, appeared before the magistrates at Callington and were imprisoned.

Once there was a brewery in Albaston, run by the Bowhay family. Older residents still remember Skinnard's Bakery whose premises burnt down in 1947.

An unusual feature at Albaston is the 'Welcome Tree' near the Queen's Head Hotel in the centre of the village. The tree was designed by Rosie Fierek in 2001 and 2002. The leaves and birds were designed by pupils from Delaware and Gunnislake schools. It is fun to spot the fourteen kinds of birds depicted, all of which are found in the surrounding countryside.

Today in Albaston village centre visitors can admire the Welcome Tree, made from pieces of stone, laid in mosaic fashion on the wall of a building. The tree trunk, leaves and birds all represent types of minerals mined in the area.

Below Gunnislake the short Tamar Manure Navigation Canal was dug and opened in 1801 to enable barges to get round the salmon weir on the Cornish side. There was a lock near the Tamar Bone Mill at the lower end and another by the Bealswood Brick Works. The canal could accommodate barges up to around 120 tons, allowing them to reach New Bridge where there was a turning basin. In 1942, the canal company operations ended when the business went into liquidation.

The celebrated Morwell Rocks rising directly out of the river.

Weir Head, near Gunnislake, is the tidal limit of the Tamar and the highest point that pleasure vessels can reach from the sea.

Not far downstream the river takes an unexpected turn and veers seemingly directly toward the massive wall of Morwell Rocks, as they rise to several hundred feet directly up out of the water.

Another sharp change of direction takes the river to Impham Turn, one of the great hazards for shipping on the river. To safely negotiate Impham Turn at some states of the tide takes all an experienced seaman's skill, particularly if another vessel is moving in the opposite direction.

The Tamar now makes several great loops. Suddenly visitors discovering the river by water transport reach Morwellham (pronounced Morwell Ham) on the Devon bank and are, thanks to the Dartington Amenity Trust, transported back to the nineteenth century, when the port was one of the busiest on the river.

One of the first recorded mentions of Morwellham comes in the thirteenth century. It was the outlet port for tin ore brought down from Dartmoor, which in turn made Tavistock a stannary town.

After the Dissolution of the Monasteries, Morwellham came into the possession of Lord John Russell, whose family were later to become the Dukes

of Bedford. After vast quantities of copper were discovered at Wheal Friendship at Mary Tavy, it soon became one of the main copper producing areas in Devon. It was young John Taylor from Norfolk who became manager at the mine. Taylor noticed that, due to lack of transport, mined ore was beginning to pile up. He decided that a canal should be built from the river Tavy at Tavistock to Morwellham on the Tamar, which would enable the copper ore to be transported to markets more quickly. Among Taylor's financial backers was the Duke of Bedford. His Grace, who owned all the land through which the proposed canal would pass, was obviously an astute man. He realised that he could charge those who used the canal a tonnage toll. Later, Taylor was asked to draw up a detailed plan for the four-mile long canal scheme. He realised that there were obstacles to overcome. An aqueduct would carry the canal over the river Lumburn. Morwell Down would be pierced by a tunnel a mile and a half long and in places 350 feet deep, emerging from a portal some 250 feet above the quayside at Morwellham. Finally an incline railway, powered by waterwheels, would enable cargoes to be moved between the canal and the quayside. The canal took fourteen years to build and opened in 1817.

This was a major step forward as copper from the mines around Mary Tavy and Crowndale and slate from the Mill Hill quarries could be taken to

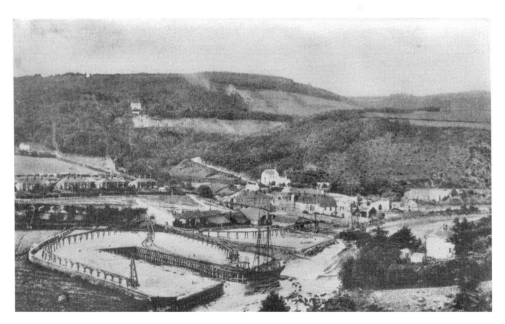

An early view looking down on to Morwellham Quay, one of the busiest ports on the river, as it was a hundred years ago. The chapel is in the centre of the picture.

Morwellham and coal, timber, lime and sand could also be transported inland. In 1844 copper was discovered at Blanchdown, which was to become Devon Great Consols Mine the biggest copper producing mine in Europe, consequently Morwellham became a boom port.

In August 1856 the royal yacht, *Victoria and Albert,* sailed into the Tamar estuary and anchored off Mount Edgcumbe. On board were Her Majesty Queen Victoria, the Prince Consort and their family. After the yacht had lain at anchor for some time an exchange of signals took place with the fort on Mount Wise. Later the party sailed up the Tamar to Morwellham Quay in the tender *Fairy.* On nearing Calstock, it was found that the *Fairy* could not proceed further as she was drawing too much water. Luckily the *Gipsy* a Tamar river steamer was nearby and could give much-needed assistance. A local newspaper tells us that Her Majesty remained unruffled, and 'without reluctance on the part of Her Majesty. She embarked on board and was conveyed to Morwellham where on the quay she had to pick her path between the piles of copper ore'. Shortly afterwards a conveyance was procured and the royal party proceeded to Endsleigh, the seat of the Duke of Bedford.

While Her Majesty was at Endsleigh an unexpected meeting took place. At Swiss Cottage, Her Majesty met elderly Mrs Bryant, who was seemingly

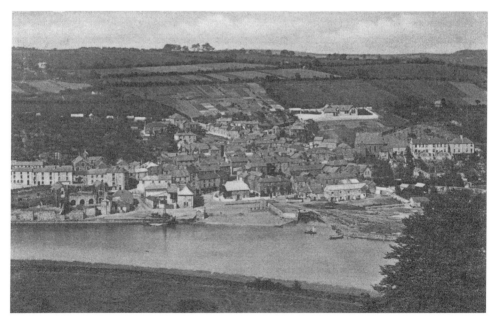

Calstock from across the river, showing the waterfront and, behind, the south-facing market gardens slope back toward the horizon.

unfazed by the royal presence and proceeded to tell the queen that she had lost a son, who had been serving with the 41st regiment in the Crimea. Naturally, the queen expressed her sympathy and promised Mrs Bryant that she should have the medal to which her son was entitled, as if he had been living. Afterwards, the medal, with a covering letter from the queen, addressed to Colonel Phipps, was received at Endsleigh, commanding him to deliver the enclosed medal to Mrs Bryant. By all accounts, Mrs Bryant's joy was unbounded on the medal been presented to her. Mrs Bryant exclaimed, 'to think that the queen had kept her promise, and how kind of Her Majesty. May God bless her.'

In 1859, the railway crossed the Tamar, which affected traffic and trade on the canal. Around this time, the great copper lodes began to run out and Morwellham's boom time, which had been linked to the fortunes of the mines during the 1870s and 1880s rapidly faded. Morwellham, along with other smaller Tamar ports, began to sink into decline. For over sixty years, Morwellham was airbrushed from memory and quickly became overgrown. In 1970, the Dartington Amenity Trust entered the equation. Research brought the port's historical significance into focus and volunteers set to work on clearing the site. Eventually buildings and quays were revealed. Today, Morwellham is an open-air museum. There are a variety of exhibits including a cooper's workshop, a blacksmith's forge, a working waterwheel, copper-ore trucks and the *Garlandstone* in its dry dock, as well as an 1860s-style shop. Another attraction are the horse-drawn carriage rides, created in 1833, along a short distance between Morwellham and Endsleigh.

The eighteenth-century atmosphere of Morwellham is created by people wearing authentic period costume and working in the old-fashioned methods. Trails lead through the woods to the exit portal of the Tavistock canal, and to the George and Charlotte copper mine, last worked in 1868. Since August 1978, visitors have been able to experience something of the miner's life underground by taking the small tramway running along the cliff edge close to the river into a deep mine adit where there are illuminated explanatory tableaux.

In 2003, to mark the twenty-fifth anniversary of the mine being opened to visitors, Mr Alec Friendship the driver of the first train to carry visitors, repeated that first journey.

Disaster struck Morwellham in December 1979. Torrential rain, combined with a high tide, caused severe flooding. Morwellham suffered more than most places. Several of the displays were ruined and the outside exhibits were washed away. The Ship Inn was flooded to ceiling height. Today, small slate plaques mark the water level.

In 1933, the exit portal of the Tavistock Canal tunnel, some 250 feet above the river Tamar, at Morwellham, collapsed. The canal is four miles in length and links the river Tavy to the river Tamar by an aqueduct over the river Lumburn and a mile-and-a-half long tunnel under Morwell Down, as well as an incline plane system at Morwellham Quay. This picture shows the reconstruction team leaving the tunnel. (Mykytyn collection. Bodmin)

Okel Tor Mine is believed to have got its name from Tokelyne Torre, the name of a rock on the side of the Tamar mentioned in the Black Prince's records of 1351. In 1848, a new mine to prospect for copper, lead, tin, silver and arsenic, was proposed and two years later work started on sinking the shafts. In 1851, a new concern, the Okel Tor Mining Company was founded. The arsenic extracted was reputed to be of the best quality in the district.

Between 1859 and 1870 the mine rapidly expanded. When new shafts and levels were sunk, the deepest took the mine workings under the river Tamar, linking them with those at Gawton Mine on the Devon side. It is said that the miners working under the river could hear the thudding of the paddle steamers plying up and down the river. In 1872, tin was also discovered, but the price of ore faltered and consequently this side of the operation was short lived, and the mine was abandoned and offered for sale. Two years later, a new company took over the mine and began extracting arsenic, but this enterprise failed and went into liquidation. Another company began extracting arsenic but it too failed and was wound up in 1885. Later, the

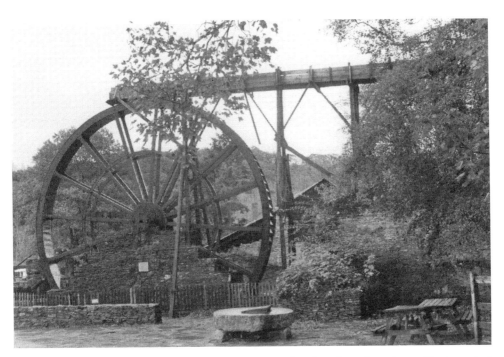

Morwellham is well known for its displays of industrial archaeology, featuring guides in period costume, a cooperage, smithy and a shop. The waterwheel is a part of the outdoor display on the quayside as well as the Tavistock Canal tunnel exit and the George and Charlotte mine.

Calstock Tin and Arsenic Works Syndicate Ltd acquired the site and began operations, but this was no more successful than its predecessors, and the mine closed in 1889. The site of the Okel Mine is now privately owned and occasional conducted tours are organised, when it is possible to view the mining relics which remain.

Calestoch, Kalestoc or modern Calstock on the Cornish bank of the Tamar is mentioned in the Domesday Book. Since Saxon times, it has been an important port, there being more than a mile of quays. The Tamar in all its moods is in the blood of Calstock people, as most of their work-a-day lives and leisure time centre around the river.

The name Goss is synonymous with Calstock and boat building. The famous James Goss boatyard was near the site of the viaduct on the Devon bank. Other industries, such as market gardening, quarrying, mining, paper-making, tanning, brick-making or brewing have been carried out here. Each has carved its own particular niche in the history of Calstock and all depend to a certain extent on the river.

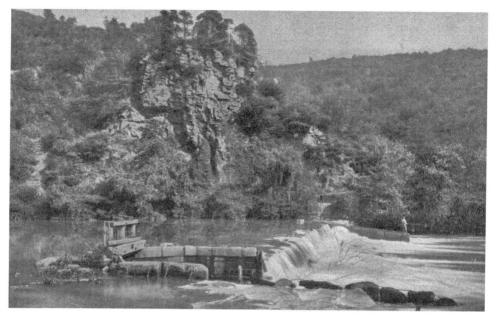

The weir across the Tamar at Calstock pictured in 1906. The village youngsters used to cross the river from the Cornish side to play in the woods on the Devon side. Crossing the weir when the tide was rising was a dare among the young blades and a way of impressing the girls!

At one time, great activity surrounded the quays, which edged the river frontage when the numerous schooners came and went, each loading or unloading their cargoes. In the mid-1860s, there were around twenty mines working within a short distance of Calstock and the ore was brought to the quays for transportation to South Wales for smelting.

One of the highlights of the year in Calstock is the annual regatta, which first started in 1837 and continued until the late 1930s. After a lapse it was started again in 1967.

In 1907, the concrete railway viaduct was built and was hailed as a blessing in disguise, particularly for the market gardeners who were then able to get their produce to distant markets more quickly. It was a common sight to see numerous boxes of flowers and fruit on Calstock railway station awaiting dispatch. During the Second World War, when the blitz on Plymouth was at its height, numberless Plymothians travelled nightly by train to the comparative safety of Calstock to escape the bombing.

In 2003, a team of archaeologists from Exeter University were working on a project concerning silver mining in the Tamar valley when their attention

Calstock viaduct under construction in 1907. It was opened for traffic the following year and carried the railway over the Tamar. It enabled the market gardeners to get their produce to distant markets before their competitors and therefore could earn correspondingly higher prices. (Photograph Colin Barrett collection.)

Archaeologists at work near Calstock church where fragments of Roman pottery were found in the newer churchyard. Excavations went on to reveal a hitherto unknown Roman fort. (Photograph Calstock History Group.)

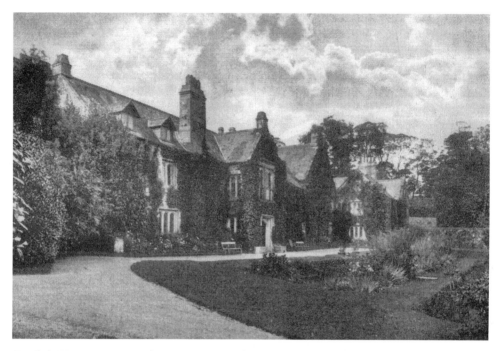

Cotehele House, a National Trust property above the Tamar near Calstock. The house has a homely lived-in atmosphere. Most of the contents actually belonged to the Edgcumbe family.

was drawn to Calstock churchyard. Here excavations along the paths were made and pieces of Samian ware pottery were found. Consequently, a hitherto unknown Roman fort was discovered. It is estimated that it was occupied for around seventy years and that probably around 2,000 soldiers were billeted on the site.

Further downstream the Tamar courses through a densely-wooded landscape, lending Cotehele House an air of secrecy and serenity. Cotehele is, according to Sir John Betjeman, one of the best Tudor houses anywhere in the county and Nikolaus Pevsner was equally gushing. Cotehele, he said, is the most extensive and important Tudor house in Cornwall. The house got its name from Hilaria de Cotehele, an heiress who brought the house into the Edgcumbe family when she married William Edgcumbe of Milton Abbot in 1353. Over the decades, the Edgcumbe family prospered and they became one of the most important in Cornwall. Later, during the troubled time of the Wars of the Roses, Richard Edgcumbe was of the Lancastrian persuasion and, in 1483, declared against the King and Crown and sided with Henry Tudor. After the abortive rebellion Edgcumbe came back to Cotehele, pursued by the king's local agent, Henry

Trenowth of Bodrugan. Trenowth quickly initiated a thorough search of the house and estate by his men, during which Edgcumbe spotted an opportunity to escape and ran toward the Tamar. On reaching the Tamar, Edgcumbe put a stone in his cap and threw it into the river. The splash alerted Trenowth and his men and, minutes later, seeing the cap floating in the water, assumed that Edgcumbe had drowned himself rather than surrender. Seemingly, the ruse worked, but Edgcumbe, however, had hidden among the bushes by the river where he stayed until it was safe to move. Shortly afterwards he was able to escape to Brittany.

After a few years, Edgcumbe was back at Cotehele where, in gratitude for his escape, he built a stone chapel down by the river to replace a similar building erected in 1411. The chapel is dedicated to saints George and Thomas Becket, was restored in 1620 and again in 1769. Later, Edgcumbe managed to join Henry Tudor and fought with distinction at Bosworth, being knighted on the field. Afterwards he was appointed ambassador to Scotland.

At Cotehele Edgcumbe supervised the expansion of the house, building the gateway and the chapel. He also realigned the south side drive as well as the buttressed barn and gatehouse. He died at Morlaix in Brittany in 1489.

Piers Edgcumbe, the son of Richard, who was also a great soldier, inherited Cotehele and was knighted by Henry VIII. Piers married Joan Durnford, an heiress, and by 1539 he had finished the expansion of the house his father had started.

Entered directly from the court, the great hall of 1515, designed by Sir Piers Edgcumbe, has a high arched timber roof over plain limewashed walls and a seventeenth-century carved wood coat of arms of the Edgcumbe family. In the stained-glass windows there are heraldic panes showing the arms of Tremayne, Trevanion, Holland, Carew and Durnford, all of whom were landed families whose members married into the Edgcumbe family. In other rooms there are seventeenth-century verdure tapestries, family portraits and period furnishings.

The chapel, dating from between 1485 and 1489, has a barrel-vaulted roof with wooden ribs carved with Tudor Roses at the intersections. An oak screen stretches across the chapel, original green and white tiles from the fifteenth century cover the floor and there are family memorials on the walls. The pre-pendulum clock is made entirely of wrought iron and mounted on a stout upright oak beam installed in 1489. It is the earliest domestic clock in the country and has no face and only one hand. Its two original iron-weights have been replaced by one of granite. The clock is still standing in its original position and it has seldom, if at all, gone wrong. The mechanism is connected

to the overhead bell-cote containing two bells, one to summon the occupants of the house to chapel services and the other to mark the passing hours.

It was this Richard who, between 1547 and 1554, built Mount Edgcumbe overlooking Plymouth Sound. From that time, Cotehele took second place as the family later moved to Mount Edgcumbe, only spending brief periods at Cotehele which was largely left untouched. Nearly a hundred years later, Sir Thomas Cotehele came on to the scene and, though having no family connection, was in 1627 instrumental in making further additions to Cotehele house, through the addition of the Gothic-style castellated north-west tower and further bedrooms. Sir Thomas Cotehele also managed to marry his daughter to another Richard Edgcumbe.

In 1849, Queen Victoria and Prince Albert were cruising on the Tamar in the royal yacht, *Victoria and Albert*. At Cotehele they boarded the tender *Fairy* and landed at Cotehele Quay and later visited the house.

A poignant feature not far from the north-west tower is the group of graves of the family dogs. One remembers 'Yarrow, 1876-1891. My good and faithful companion'.

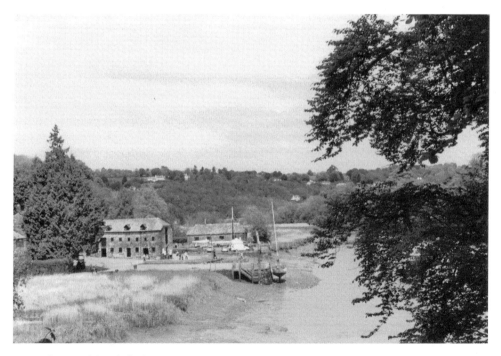

General view of Cotehele Quay.

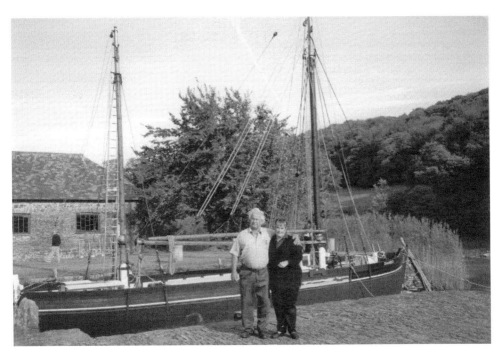

Cotehele Quay is always popular with visitors. This 2001 picture shows Charlie and Gloria Cottle admiring *Shamrock*, the last Tamar barge, which has been restored after being rescued doing service as a scrap iron store in Hooe Lake, near Plymouth.

Cotehele came into its own again when, in March 1941, the family were forced to vacate Mount Edgcumbe during the height of the blitz on Plymouth. By the time George Edgcumbe, the 5th Earl, who was obviously a man of foresight, had succeeded to the title and died in 1944, arrangements for the future of Cotehele had been put in hand. The house and the estate of some 12,000 acres would be accepted as payment towards death duties and given to the National Trust. This arrangement came into effect in 1947, making Cotehele the first house of any consequence in the country to come to the National Trust in this way. In 1965, on the death of the 6th earl, the family trustees gave on loan the staterooms, tapestries, furniture and other valuable items in lieu of estate duty.

The gardens at Cotehele were mainly laid out by the Edgcumbe family during the nineteenth century. The fifteenth-century dome-shaped roof of the dovecote, which sits in the garden, collapsed in about 1860 and has since been restored. Inside is a revolving ladder to allow easy access to the pigeon-holes. The dovecote is home to a small colony of white doves. There is a wide variety

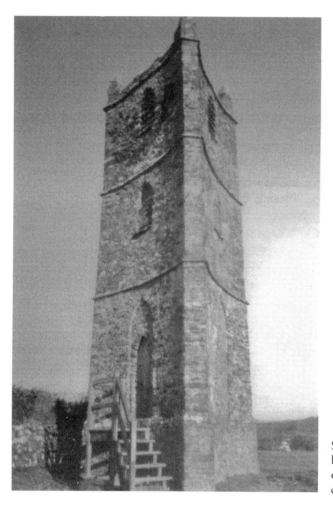

Sham church tower on high ground, to the north of Cotehele. (Photograph courtesy of Rob Furneaux)

of trees and shrubs as well as stone and water features. A series of woodland paths take visitors down to the quay and the river Tamar.

Standing in a field a short distance away to the north of the house is an eye-catcher or monumental folly. Built of local stone, the tower soars to sixty feet, with pinnacles, false windows and three concave sides, which give it a solid church-like look. The exact origin of the tower, however, is uncertain, but it is thought to have been built to commemorate the visit of George III and Queen Charlotte in 1789 and also Lord Edgcumbe's elevation to an earldom. Others favour the idea that it was simply because Edgcumbe wanted a church on his estate. Today, visitors who climb to the top can enjoy the expansive view to Dartmoor, Cornwall, over the river Tamar estuary to Maker and Rame.

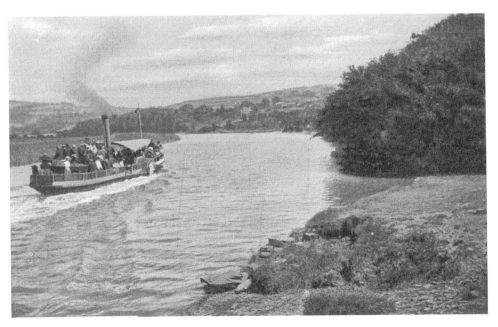

A familiar sight a hundred years ago when a steamer trips up and down the river were all the rage.

Cotehele Quay was once a popular destination among those taking paddle steamer trips up the Tamar from Saltash and Plymouth. The quay is also fascinating for its industrial relics. Once there were several lime kilns, a granary, manure stores, a brewery, stables and timber yards. One of the lime burner's cottages became the Edgcumbe Arms, and today is a popular restaurant.

At one time, fruit growers from all over the valley brought their produce to the quay for transportation to city markets. Later, it was ferried across the river and taken to Bere Alston railway station. Now in dock is the *Shamrock*, the last Tamar barge, which for around seventy years regularly plied around Plymouth and up and down the river. *Shamrock*, a flat-bottomed barge, rigged as a ketch with a shallow draft making her ideal for work on the river and in a maze of shallow creeks was built by Frederick Hawke of Stonehouse, Plymouth for Mr Tom Williams of Torpoint and first registered in September 1899. For some twenty years she worked round Plymouth breakwater carrying various cargoes including coal, limestone, bricks, and sand.

During the First World War, *Shamrock* had a more important role. She was used to carry shells from Plymouth Sound to Ocean Quay. After the arrival of the railways, her usual trade declined and she was sold to a group of stone quarrymen whose cargo she carried for the next forty or so years. In 1962, she

An expansive view of the river from the reed beds at Green Bank, St Dominick. The outskirts of Bere Alston are just visible on the horizon.

was found dredging for tin ore in St Ives Bay and was later involved in wreck salvage in Mounts Bay, and at one period she was a diving tender in Plymouth harbour. By 1970, *Shamrock* was a deserted scrap iron store in Hooe Lake, the boat cemetery at Plymouth.

In 1973, a Plymouth man, John Fildew, intended to restore *Shamrock* privately and save her, after a seventy year working life, from coming to an ignominious end. Fate, however, intervened and she was spotted by the National Maritime Museum. Coincidentally, the National Trust were in the throes of restoring Cotehele Quay and the two bodies came together and a restoration package and the opportunity to bring *Shamrock* and new life to Cotehele Quay was formulated. *Shamrock* arrived at Cotehele Quay, in March 1974 and, after protracted investigations, it was decided that the restoration to a standard where she could sail again was feasible. In April 1979, five years after she arrived under tow in a sad condition, *Shamrock* floated on an evening tide. Sea trials in Plymouth Sound followed and then in 1983 she sailed to Fowey — a re-enactment of her 1899 maiden voyage. Today, *Shamrock* makes occasional forays to Plymouth and farther afield to her former ports of call. The grand old lady of the Tamar is a focal point for visitors to the quay at Cotehele.

8

AROUND HALTON QUAY, AND FROM PENTILLIE TO SALTASH

For the first time in the whole of its length, the Tamar displays its estuarine beauty for all to see as it sweeps away from Cotehele.

Soon the river flows sedately past Green Bank, the home of Mr and Mrs Derek Scofield, which is discovered at the end of a long narrow track, making it an ideal escape from the stresses and strains of the modern world. The front garden literally edges on to the massive reed beds, which seem to balance one another on either side of this stretch of the river between Bohetherick and Halton Quay. It is only when the visitor (Greenbank is private property) treads the duck boards, inundated at high tide, that the full extent of the swaying ocean of reeds can be fully appreciated. The reeds, standing several feet tall, offer shelter to duck and several other kinds of water fowl. Looking over the reeds, the roof of Halton Quay chapel is just visible and no alien sound shatters the peace. The peace was once shattered, however, from an unexpected quarter. The National Trust suddenly announced in 2005 that they intended to re-flood about 50 acres of reclaimed land at Hay Marsh by Cotehele. The proposal incensed the residents of St Dominick who were concerned about the Cotehele Wetland and Restoration scheme. An opposition group, 'Save our Dyke in the Tamar', was launched to challenge the National Trust proposal and to stop the flooding. Several hundred signatures of support were collected from around St Dominick and also from Bere Alston on the Devon side of the river. The group was concerned about possible changes the scheme may bring to an area of outstanding natural beauty, the loss of the view, farmland and the navigability of the river. Counter views were traded and challenged. Eventually the National Trust dropped their proposal and a legal wrangle was avoided. The farmer now has a longer lease on Hay Marsh and the National Trust and English Nature combine farming with nature more in mind.

The Tamar making one of its characteristic sweeps by Bohetherick before it reaches Cotehele House and Quay.

Nearby at the side of a lane leading to Greenbank, and canopied by trees, is the tiny slate-roofed, stone-built Holy Well of St Indract. It was near here that St Indract, the son of an Irish King and brother of St Dominica, together with a group of companions, struck land in the seventh century. By all accounts, at one time a trout was resident in the Holy Well to keep the water clean. Water from the well was once used for baptisms at St Dominick parish church. The black wrought iron gate protecting the well has a cross in its design, but closer inspection reveals a surprise as its catch takes the form of a devil's tail!

Across the river is North Hooe Farm and, on the horizon, the edge of Bere Alston. It is possible to glimpse the train crossing the embankment by Bere Alston. Local people know that when the train can be heard crossing Tavy Bridge it is a sure sign of rain. A short distance away is Halton Quay, a favourite spot for those who like to fish with rod and line. A small granite memorial remembers Edd North who, according to local artist Mary Martin, was an engineer from 'up country' who came to live at Halton Barton Barn and fell in love with the Tamar.

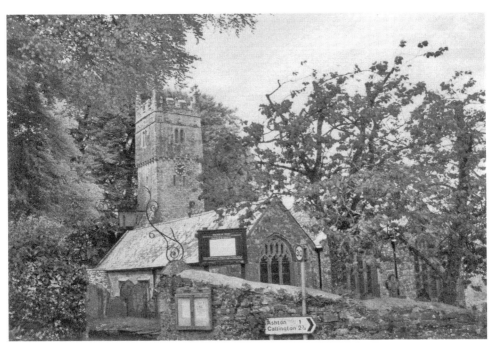

St Dominick's church was dedicated to St Domenica in 1259 by Bishop de Bronescombe. The Delabole slate for the roof was brought up the Tamar to Halton Quay. It is recorded that in 1871 there was a service to mark the restoration, a large number of people came up the river on the steamer *Eclipse* from Devonport and Plymouth.

Nearby Halton Barton was once a monastery and Chapel Farm was a nunnery. Local legend has it that there was secret tunnel between the two, though it has never been located. Frances Drake had a disagreement at the house, the home of an admirer of his wife. In the sixteenth century, Anthony Rous, a friend of Richard Carew who made and wrote his *Survey of Cornwall*, lived at Halton Barton.

Halton Quay, one of the main trading quays on this stretch of the river, was once a place of great activity. Lime and coal were regularly moved from the quay and granite was brought down from Hingston Down and shipped all over the world. Lime kilns still stand just above the high-tide line at Halton Quay. The first references to a lime kiln here come in the early years of the fifteenth century. Lime was moved great distances and it is known that when Launceston Castle was in need of repair the lime for mortar was brought from Halton. Over the decades, the kilns have been leased several times. In 1860, Elizabeth Bluett, a widow from Bath, leased it to Messrs Perry and Spear who were important merchants based in the valley. They also leased storehouses,

Above: The picturesque chapel of St Indract, a focal point for local artists at Halton Quay.

Left: The old lime kilns at Halton Quay were first recorded in the earliest years of the fifteenth century. When the lime kilns ceased operating in 1916 they were believed to be the last working in the Tamar valley.

Halton Quay is a favourite spot for anglers of all ages. This photograph shows young Keiron Sanders, who has had a bite, while dad Paul looks on.

Pleasure craft passing Halton Quay, with North Hooe farm on the opposite bank. This part of the river Tamar and Halton Quay in particular is beloved by countless people. One was Edd North to whom a small granite memorial has been erected, but he appears to be something of an enigma. No one seems to know exactly who he was, so a mystery remains!

granaries. Timberyards, an ore yard and much else at Halton Quay. Currently, plans are in hand to cut down the ash trees growing from the top of the kilns and to remove the smothering ivy, and then restore the building. Hopefully the face on the kiln, one of only two in the whole valley, will again be revealed. Vast quantities of fruit, flowers and vegetables were brought to the quay and sent off to local markets and those further afield.

Pride of place at Halton Quay is given to the chapel of St Indract. The Grade II listed stone and slate roofed building has been at various times a coal merchant's office and a clerking office, connected with the movement of goods to and from the quay. The space under the chapel was used by local salmon fishermen for storing their nets and tackle until the demise of salmon fishing in the area. The building saw another reincarnation in June 1959 when it was consecrated as a chapel and leased by the church from the then owner, Captain Coryton of Pentillie Castle, for an annual rent of 2 shillings and 6 pence (12½p). The chapel can accommodate eighteen worshippers. The Archdeacon of Bodmin, the Venerable W. H. Prior, conducted the consecration service, during which he delivered a message from the Bishop of Truro, Dr E. R. Morgan. He also dedicated a bible presented by two of the Sunday school pupils, Maureen and Linda Roberts. The vicar of St Dominick, the Reverend R. G. R. Perry-Gore, conducted the remainder of the service. The congregation numbered around 200, including a party of Wrens who had paddled their canoes from Plymouth. A few years ago, the chapel had fallen into disrepair and was deemed unsafe for services. Local residents decided that the building must be restored and a programme of work, costing several thousands of pounds, was launched. Private donations from local residents enabled a new altar and furnishings to be installed. Local artists undertook to provide specially-designed wall panels and apparently they were paid in wine!

A singular arrangement was agreed with the trustees of the closed Methodist chapel at Polborder. Four pews were provided in exchange for a donation toward the upkeep of the graveyard there. On this occasion the chapel was rededicated by Roy Screech, the Bishop of St German's. The chapel is now an oratory for the parishes of St Dominick, St Mellion, Landulph and Pillaton. Evensong is regularly held at the chapel and proves highly popular with both local people and visitors.

Beyond Halton Quay the Tamar makes a great sweep as it reaches Pentillie Quay, where the parkland climbs up to Pentillie Castle. The castle, built by Sir James Tillie in 1689, is one of the secrets of the valley. At one time, a farmhouse and a chapel occupied the higher stretch of land affording wide-ranging views of the river Tamar. Most great houses have their ghost or mystery and Pentillie

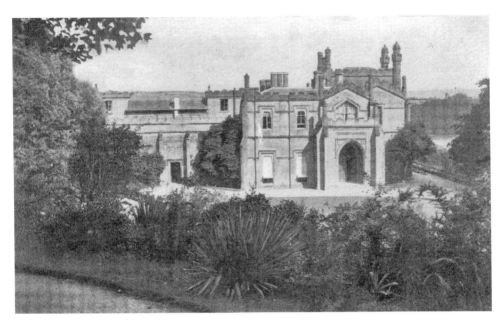

An old view of Pentillie castle, built in 1689, standing in extensive parkland above the Tamar.

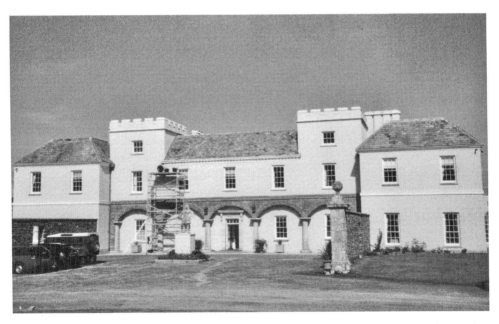

Pentillie castle was occupied by a reclusive lady and stood for around thirty years as if trapped in amber. The castle and estate has been given a new lease of life and is vibrant and happy again.

is no exception. In 1689, Sir John Coryton died a painful death in somewhat peculiar circumstances. The local rumour-mongers firmly believed that he had been poisoned and suspicion fell firmly on the shoulders of James Tillie. What is certain is that Tillie and Lady Coryton were 'friendly' and, after Coryton's death, they married.

Sir James Tillie was an odd character who firmly believed that within two years after death he would experience resurrection. When he died in 1712, he left a set of peculiar instructions for his family. He stated that his body should be seated on a chair and wired into position. The chair was to be mounted on a stone plinth in a tower-like mausoleum built in a part of the estate called Mount Ararat. He wished to be dressed in his robes, wearing his wig. A chest containing all his personal possessions was to be placed by his side. Food and drink was to be placed daily before him in the mausoleum. Strange as it may seem, all these instructions were duly carried out. However, two years later he was finally removed for burial and a stone statue put in his place. It remains a mystery exactly where Tillie is buried but current investigations seem to favour Pillaton. Tillie's mausoleum still stands in the park and ironically some of the views of the Tamar's great meanders can be seen from the track to and from the steps of the mausoleum.

Through marriage Pentillie again came into the Coryton family in 1770, and their descendants still live at the castle. Forty years later, in 1810, extensive alterations were made to Pentillie, when the mansion was revamped in the Gothic style to designs drawn up by architect William Wilkins and landscape architect Humphry Repton. During the Second World War, Pentillie was requisitioned as a maternity hospital. In 1960, three wings were torn down and later rebuilt to a newer design.

In more recent times, Kit Coryton, a reclusive lady, lived alone at Pentillie for something like thirty years, keeping only a skeleton staff. She seldom received visitors, other than a few special friends, and the only callers were tradesmen. Until recently, relatives living close by were forbidden to set foot on the estate and could only glimpse the house through the trees from beyond the Tamar. The house has extensive gardens and a mature lime walk. The orchard has been planted with the varieties of cherry trees once grown on the estate. Many years ago, the Cherry Festivals held at Pentllie were popular. The parkland of over 2,000 acres sweeps down to the bathing house on the Tamar tidal estuary. In recent years, the present Coryton family, who inherited Pentillie, have breathed new life into the house.

By Pentillie the Tamar make some spectacular serpentine coils and enhances the view to Cargreen.

Statue of Sir James Tillie, the larger than life character who lived at Pentillie and who claimed a knighthood to which he was not entitled.

The mausoleum, a square, three-storey building on Mount Ararat at Pentillie. After Tillie died in 1712, he sat here, unburied for two years awaiting resurrection. Eventually Tillie was buried and an effigy placed in the mausoleum. Strangely, this creepy spot offers spectacular views of the Tamar and its great serpentine coils as it winds pass Pentillie.

The picturesque quay at Pentillie looking toward Halton Quay and Cotehele.

Cargreen was at one time in the midst of the market garden area and most of the families hereabouts were involved in the industry. The ferryman was always ready to convey market garden produce across the river so that it could be transported to market by rail from Bere Alston. Smuggling was rife at Cargreen and in the surrounding area in the eighteenth century, when it was necessary for a revenue rowing boat to be stationed here. The Spaniard's Inn at the bottom of the long street was once called the 'Royal Oak' and its origins go back many years. The inn was given its present name by a previous landlord, who wanted to remind his patrons of former times when Spanish pirates sailed up the Tamar on raiding forays. It was rebuilt several years ago but still retains its old-world charm.

Today, Cargreen is greatly favoured by the sailing community and is a pleasant spot to while away a few hours, take a noggin or two, and watch the craft on the Tamar.

Below Cargreen and opposite Landulph, the Tavy joins the Tamar, the only tributary of any consequence since it welcomed the Inny, several miles upstream.

One of the greatest surprises on the entire length of the river Tamar is Landulph church on a quiet tidal creek known as Kings Mill Lake. A church

Cargreen village inn was once called The Royal Oak. This stretch of the Tamar is a popular spot for boating enthusiasts and further along the river bank, provides quiet spots for ornithologists

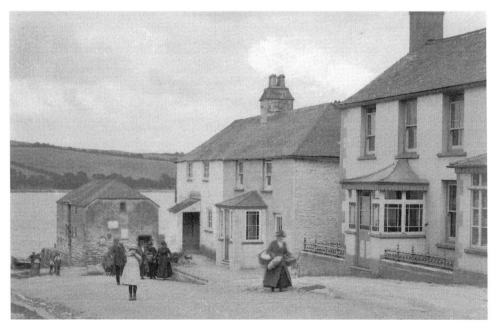

A familiar sight in nineteenth century Cargreen. It would appear that these ladies have just disembarked from the ferry after successfully selling their produce at market and are now laden with shopping.

was established here by the creek in Saxon times and then rebuilt by the Normans. The original dedication was to a Celtic saint, Landylp or Landilpe, but in the fifteenth century it was re-dedicated to St Leonard. At this time, there was much rebuilding of the nave and arcade and restoration of the roof, which incorporated old timber and roof bosses. Windows were installed and the inner porch added. The rood screen and the array of fifteenth-century bench ends are remarkable and there are several curiosities. The most remarkable of all is a brass memorial plaque bearing a double-headed Byzantine eagle with its feet firmly on two massive embattled gateways, the whole surmounted by a Byzantine crown. It is attached to the church wall and commemorates Theodore Paleologus, whose family, the Paleologi, can be traced back to the eleventh century. It is this memorial which brings visitors, including royalty, to Landulph. When Constantine XI was killed at Constantinople, his descendants fled to Italy where they settled. Exactly how Theodore came to England remains uncertain but he found refuge at Landulph. Some scholars believe that Paleologus was taken up by the Killigrew and Lower families and then given Clifton, one of their residences in the parish. Later, in 1615, he married an Englishwoman, called Mary Balls. Together they lived quietly at Landulph. Few people realised that a man who could have been an emperor was living in their midst. In 1795, some local men opened Theodore Paleologus' coffin. Surprisingly, the body was well preserved and was reported to be of more than common height with a long white beard. By all accounts, the coffin was opened again in 1840. In July 1962, the Queen and Prince Philip, who is a descendant, came to Landulph to inspect the tomb, but on this occasion the coffin lid remained closed.

Over four hundred years later, another man was to put Landulph firmly on the map in an entirely different way. He was Adrian du Plessis, a South African soldier, who had fought in France during the First World War. At the end of the war, and having been recently demobilised, instead of going home he decided to stay in England to study agriculture. He came to what was then the Duchy Home Farm at Stokeclimsland. Later, when a poultry farm was being set up at Landulph, he was offered the job of manager, which position he accepted. Shortly afterwards he met and married local girl Mary Spear. A few years later, the Duchy gave up the poultry farm and Adrian saw an opportunity for himself and took on the tenancy of Lower Marsh Farm. Several acres of apple orchards were planted and Lower Marsh Farm became known for its cider apples and, when that market began to wither, the orchards, like others in the Tamar Valley, were torn out. Another change of direction took Adrian du Plessis into the flower growing industry.

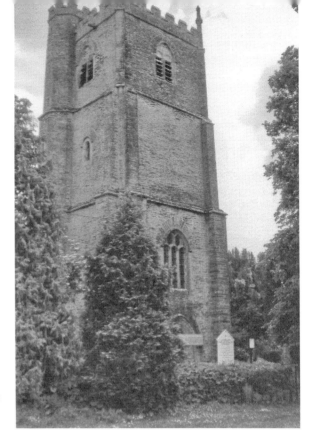

Landulph church is one of the most fascinating churches in the Tamar valley.

Peter du Plessis at Lower Marsh Farm (Photograph by Peter Gregory from the du Plessis private collection.)

Dan du Plessis at Lower Marsh farm. (Photograph by Peter Gregory from Peter du Plessis' private collection.)

In the early 1940s, Dan joined his father, and then, after the death of Mr du Plessis senior, carried on the business with his mother. Seemingly, it was at the first Tamar Valley Flower Show, held at the Devonport Guild Hall after the Second World War, that Dan was struck by the daffodils on show and from that was born the idea of commercially growing, marketing and breeding new strains of daffodil. Confidence grew and during the 1950s the du Plessis name regularly featured among the award winners at the show. In the early 1960s, the brothers, Dan and Peter, entered into formal partnership and began business as du Plessis brothers. Around this time, they decided to increase the bulb side of the business. They also began selecting new seedlings, breeding and naming them. A turning point came in the 1970s, when severely cold winters plagued the Tamar valley and these were followed by scorching hot long summers, which played havoc with the vegetable and flower crops.

The Tamar valley climate seemed to favour early spring flowers, particularly daffodils and narcissi, and they seemed to be the answer. The du Plessis brothers were able to supply local markets up and down the country before many of their potential rivals. Eventually daffodils and narcissi took over their lives and the brothers were recognised by the Daffodil Society. At one time, several hundred different varieties of daffodil and narcissi were grown at Lower Marsh Farm. They named about forty daffodil and narcissi varieties, among them Noss Mayo and Tamar Fire, Bere Ferrers, Chenoweth, Kingsmill and Haye. Since that time, du Plessis-bred daffodils and narcissi have spread to New Zealand, Canada, America, and to several countries in Eastern European and Russia. At one period, in recognition of what he had achieved for the daffodil industry, Dan du Plessis was presented with the prestigious Peter Bart memorial cup by the Royal Horticultural Society. The du Plessis brothers regularly took prizes at the national daffodil show and they became leading figures among the daffodil growing fraternity. At one period, Dan du Plessis was elected vice president of the Daffodil Society, and he was also one of the driving forces behind the formation of the Cornwall Area Bulb Growers Association. Lower Marsh Farm was also honoured by a royal visit when Prince Charles, Duke of Cornwall, visited Landulph. The brothers retired in 1990, at which time the daffodil fields were approaching twenty acres in extent. Today, the name of du Plessis is still recalled with something resembling reverence whereever daffodils are grown in the Tamar Valley.

Botus Fleming church is well worth a visit, though it narrowly escaped damage during the Second World War when crippled German bombers ditched their payload on the village. Two bombs just missed the church and others caused damage in the village. Fortunately there was only one fatality.

Nearby is the parish stone-built animal pound, one of only a handful in Cornwall, which was restored to its former glory in 2002.

Botus Fleming was known as 'Little Japan' or 'The Cherry Orchard Village' and special spring-time excursions to see the blossom were laid on from Plymouth and Saltash. During the cherry picking season, sailors came to the village from Plymouth to help harvest the fruit. They are remembered as being expert pickers who were particularly adept at manoeuvring the long ladders.

The strawberries and a wide variety of soft fruits grown here were reckoned to produce the best yield and to be the best flavoured in the Tamar valley. An old resident recalls it was all due to liberal quantities of dock dung being spread on the fields. Apparently this was a pungent smelling mixture of sweepings from Devonport market which was regularly brought up to Moditonham Quay by barge. The mixture was spread on the fields on arrival as it was not permitted

Landulph, a floral corner in the Tamar valley. In this view the spring carpets of daffodils make a sight to lift the heart and inspire any budding Wordsworth.

Open days were always popular occasions when crowds of flower lovers descended on Lower Marsh Farm. (Photograph Peter du Plessis private collection.)

to allow dock dung to rest on the quay overnight as the pungent smell pervaded the village and made life unpleasant.

At one time, one of the more disreputable wayside inns in the lower reaches of the Tamar valley was The Fighting Cocks near Botus Fleming. The inn was a magnet for drunks, thieves, rowdy yokels and undesirables, whose coarse behaviour was fuelled by liberal amounts of drink. The ringleader of this unruly behaviour was none other than John Bennett, the landlord of the hostelry who came into conflict with the steadier law-abiding people of Botus Fleming. There is a mystery surrounding the Fighting Cocks Inn which involves a servant girl, from Plymouth. The girl was making her way to visit friends at Stokeclimsland between Callington and Launceston and is believed to have called at the inn and disappeared. A thorough search of the premises and immediate district was made but no trace was found. Not surprisingly, the finger of suspicion pointed to the Fighting Cocks and John Bennett, the landlord, but no sighting had been made nor could any misdoing be proved. Gossip surrounding the suspicious disappearance and the fate of the girl persisted. The upright villagers of Botus Fleming were becoming desperate to get the Fighting Cocks closed down.

Botus Fleming, once the centre of the cherry orchard area. Here the church is pictured, through the cherry blossom, as seen by George Elllis in 1958.

Fate seemed to take a hand when Nicholas Haley, a butler at Pentillie Castle, and a group of Methodists, having no regular place to meet, began holding meetings in the fields and orchards near the village. When Haley's allegiance to the Methodist cause was discovered at Pentillie castle he was dismissed from his position. By this time, Botus Fleming people realised that the Methodists may be a way of forcing the closure of the Fighting Cocks. The turning point came when Squire Carpenter of Moditonham joined the group. Carpenter was a man of means who promised £100 toward the cost of building a chapel on his estate. The chapel was duly built and, against all odds, it flourished. Later, the inn landlord's health failed and the Fighting Cocks closed its doors. On his deathbed Bennett was heard to cry, 'keep her away from me' several times. The story, however, does not end with the Bennett's death. Prior to the outbreak of the Second World War, when workmen were widening the road, the Fighting Cocks was demolished and a skeleton, thought to be that of the servant girl, was found. Were the remains those of the servant girl? Was she murdered? Was the landlord or another patron responsible? This part of the story remains a mystery to this day and probably always will!

Situated in a field a short distance away on the East Town estate at Botus Fleming, is one of the strangest memorials anywhere in the Tamar valley. It commemorates William Martyn, an eccentric Plymouth Physician, who died aged sixty-two years old in November 1762. William Martyn firmly believed that on his death, whenever it came, he would be ready to meet the Almighty and it was immaterial where his body was buried. Martyn made it clear to his relatives that they were not to spend large amounts of money on his funeral. He also gave them a list of instructions to which they were to adhere. He stated that his corpse was not to be washed, that his waistcoat should not be removed, that a hearse should take his coffin to a high barren spot in the middle of a nearby field for burial. That six poor men of the parish who were not receiving parish pay should each be given a new suit of clothes, a hat and a pair of shoes. His executrix, at her own expense, should see that a monument was erected to his memory, and that it should never be destroyed. The monument was a square block of granite on the top of which rested a six-foot pyramid, its total height being around 12 feet. The whole structure was surrounded by iron railings. It was situated so that it was away from public view. Martyn was a Catholic. According to his epitaph he was an honest, good-natured man, willing to do all the good in his power to all mankind and not willing to hurt any person. Several years ago, vandals toppled the monument, and over time the top portion lay across the rusting railings and it became neglected. In recent years, the monument has been set upright and the railings have been repaired.

One of the quietest places on Kingsmill Lake is Moditonham Quay, where generations of local youngsters have learnt to swim. It is reached from Botus Fleming, passing the village inn through the gates of Moditonham House and following a long narrow lane. The Valletort family lived at eighteenth-century Moditonham House where the commissioners of William of Orange treated with the Earl of Bath for the surrender of the castles at Pendennis and Plymouth. At one time, Moditionham was the home of Michael Loam, who did much to improve the working conditions of the miners. He invented the Man-engine, a device which enabled miners to get to and from their working levels without climbing almost vertical ladders, before starting and after leaving their day's work.

After Moditonham and Kingsmill Lake the river flows by Skinham Point, Warleigh Point, Warren Point and South Pill, and gathers size to slide pass the Ernesettle area of Plymouth.

It then makes its presence felt at Saltash.

9

SALTASH AND TORPOINT
TO THE SEA

Saltash, anciently known as *Essa*, is a Cornish frontier town with a proud history stretching back to the beginning of time. It was granted its first charter in 1225. One of the more important duties assigned to Saltash is that of flying the Cornish flag on the bank of the river Tamar and holding firm to the town's Cornish identity in the face of the ever-present threat of absorption by the additional territorial designs of its voracious neighbour, Plymouth.

The life of Saltash has always been linked with the Tamar. The oldest street in the town is, appropriately, Tamar Street. Saltash was leased a number of activities, barges, oysterage, fisheries and buoyage granted by Queen Elizabeth I in a charter dated 1535. These privileges became known as the 'Liberty of the Water Tamar' and were held until 1900.

The ferrymen were never certain of the identity of their passengers. Legend has it that on one pitch black, stormy night, a Saltash fisherman, who was moonlighting as a ferryman, rowed his last passengers over the river to Plymouth. He was about to start his return trip when he was hailed by a stranger who requested to be taken back to Saltash. During the crossing the passenger enquired about the contents of a Cornish pasty. The fisherman explained that there could be a variety of fillings, including the devil himself if he were to set foot in Cornwall. Immediately the passenger let forth a string of oaths, jumped over the side of the boat and waded back to the safety of the Devon bank, and vanished into the night. The experience troubled the fisherman throughout the remainder of the night and early next morning he related the experience to a companion and together they rowed across the river and searched the foreshore. There, at the water's edge, so the story goes, were the distinctive marks of cloven hooves. The fisherman realised that he had been rowing the Devil himself to Cornwall and he vowed never to ferry anyone over the Tamar

again. This is how, so the legend tells, the devil was kept from setting foot in Cornwall and, to this day, the Cornish are said to be waiting their opportunity to put him in a pasty.

There are several architectural gems in Saltash. One is Mary Newman's cottage, which dates from 1450, in the old port area. Mary Newman lived in the cottage with her parents and married Francis Drake in July 1569. He was twenty-four years old and she was aged seventeen years. Drake, in later years, made his circumnavigation of the world and was knighted. In 1580, Sir Francis and Lady Drake became mayor and mayoress of the city of Plymouth, and in the same year they purchased Buckland Abbey.

When the last occupant moved out of the cottage in 1974 it was in urgent need of repair, and the Tamar Protection Society began restoring the dwelling, in a programme that took ten years to complete. The Lord Lieutenant of Cornwall officially opened it in 1984. In recent years, following the death of Mr Frank Elliott, the Tamar Protection Society, with help from the Saltash Town Council, took over Elliott's grocery shop in Lower Fore Street, which opened for business in 1902 and closed in 1973. It is now a museum.

Mary Newman was born in Saltash, lived in this cottage with her parents and became the first wife of Sir Francis Drake. There has been a dwelling on the site since the twelfth century. The present house is thought to be mainly sixteenth century and it is arguably the oldest Tudor building in Saltash. It was restored by the Tamar Protection Society and is open to the public.

The painted façade of the Union Inn on the waterfront at Saltash. This started as a patriotic gesture by the landlord to mark the anniversary of V.E. Day. The giant Union Flag caught the imagination of the public and it was decided not to remove it. It has become something of an eye-catcher for those crossing the Tamar by road or rail. The gable end murals are the work of David Wheatley.

In the nineteenth century regattas became all the rage. The Saltash regatta started in 1835 with competitive rowing and sailing events on the Tamar. Over the years there have been both male and female rowing crews. During the nineteenth century, a Saltash woman, Ann Glanville, and her all-female crew were famous. On one occasion they rowed to France, and they competed at regattas nationally, often out-rowing the best men's teams. Over time the regatta became a highlight on the Saltash calendar, but when war came in 1914 it was discontinued. Later, it was revived but declined again in the 1930s and was curtailed during the Second World War. Another revival came in the 1950s but decline set in and for a time its future was in doubt. Fortunately, a resurgence of interest came in 1963, and it has now become a well-established event. Today, at regatta time gig teams from over a wide area descend on Saltash in order to compete, and canoeists also show their prowess on the river.

The Tamar, now seemingly jammed in between Plymouth and Saltash, is greeted first by the 1961 Tamar Road Bridge and then immediately by

Since this photograph was taken in 1970, the Tamar road bridge has been widened and strengthened to cope with the increased volume of traffic.

Isambard Kingdom Brunel's 1859 Victorian masterpiece, the Royal Albert Railway Bridge. The idea of a Tamar road bridge began soon after the end of the Second World War when road traffic congestion first started to become a problem. The ferry crossing the river Tamar from Saltash to Plymouth found it increasingly difficult to cope with the volume of traffic and queues became legendary. In 1950, the idea of a Tamar road bridge between Saltash Passage and Plymouth was launched at a meeting between Plymouth City Council and Cornwall County Council. The Bill, seeking permission to construct a road bridge, was submitted to parliament and later to the House of Lords and Royal Assent was given on 27 July 1957.

The project, which required the demolition of fifty houses and ten shops, started in 1959 and took two years to build. The bridge is 50 feet wide and 1,848 feet in length. The pillars are each 240 feet high, 14 feet square at the base and 9 feet square at the top. The walls are 2 feet thick and built of reinforced concrete.

In 1996, Cornwall County Council and Plymouth City Council had to conform to European legislation directive regarding vehicular weight on bridges, so they took the opportunity to add two new traffic lanes. A Private

Bill was presented to the House of Commons in November 1996, which was given Royal Assent in July 1998 and was known as The Tamar Bridge Act 1998. Work began in March 1999 and by December 2001 the new lanes were opened. This was the first time that such major improvements had been made to a bridge while the structure remained open to traffic. The Tamar Road Bridge was originally opened by Her Majesty the Queen Mother in April 1962, and at that time it was the longest suspension bridge in the country.

Her Majesty the Queen Mother, to whom tradition was paramount, was presented with a pair of scissors with which to cut the ribbon to officially open the bridge by the managing director of the Cleveland Bridge and Engineering Co., Mr J. R. Dixon. Afterwards, Her Majesty delved into her handbag and gave him half a crown (12½p) in return. This gesture was to honour an age-old custom decreeing that when anyone is given either a knife or a pair of scissors, a coin is traditionally given in return, was to strengthen and not to sever the friendship. According to the *Western Morning News*, on the opening day 50,000 vehicles crossed the bridge. Forty years on, HRH the Princess Royal opened the new bridge configuration, which gives the bridge a life expectancy of 120 years.

Standing next to the Tamar road bridge is Isambard Kingdom Brunel's Royal Albert Bridge carrying the single-track railway line from Devon into Cornwall. When the bridge was completed Brunel was asked how long he expected it to remain standing he replied, 'One hundred years' and then, after a moment, went on to say, 'After that time it will be no longer needed'. In this prediction Brunel was totally wrong. At the time of writing the Royal Albert Bridge has just celebrated 150 years since its official opening and it is as important today as it was all those years ago.

The Cornwall Railway Company received its Act of Parliament for a line to be built from Plymouth, over the river Tamar and on to Falmouth in 1846. They immediately appointed Isambard Kingdom Brunel, one of the best engineers of the time, to design and oversee the construction of the bridge. Brunel thought that a bridge over the Tamar was impossible. He preferred the idea that a steam ferry to carry railway rolling stock over the river was the answer, but under the terms and conditions of the act, it was only permitted for the river to be crossed by a bridge at this particular point.

Brunel submitted designs for two timber bridges, one of seven spans and another of four spans, but the Admiralty turned this down as being too low. They insisted that there be only one pillar in mid-stream and the lowest part of the bridge platform be at least 100 feet above the water at high tide, so that their sailing ships moving on the river would not be impeded. Brunel then came

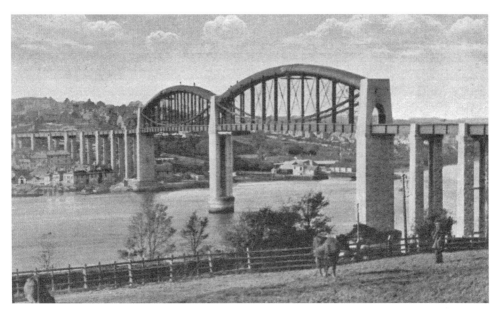

The Royal Albert Railway Bridge, designed by the great engineer Isambard Kingdom Brunel, is not the oldest Tamar Bridge crossing but it is certainly one of the grandest.

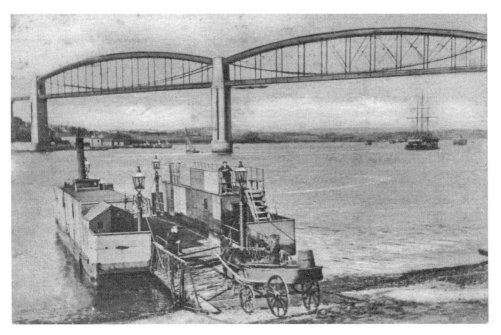

The Royal Albert Railway Bridge. In this picture a ferry is being loaded at Saltash. A plaque in Old Ferry Road tells that the last ferry sailed on 23 October 1961 after more than 700 years service.

up with the idea of a wrought iron bridge. In addition to the one central pier and the height issues there were certain factors and conditions which Brunel had to take into consideration when he was drawing up his plans.

Brunel's newest set of plans showed that the bridge was tubular in design with one central pillar. Each tube was to be 1,100 feet in length with land spans at either end of the bridge, seven at the Devon side and ten on the Cornish side. There would be two spans each of 445 feet, the top members to be huge wrought iron tubes carrying the single track. The plan was closely scrutinised and eventually given the approval of the Cornwall Railway Company and the Admiralty and work could now go ahead. Test borings into the river bed rock were made and excavations began in 1848. A giant hollow cylinder with a bottomless chamber at the base was constructed on the Devon side and later bolted together in the river. It was lowered on to the exact point where the central pier was to be built. The sharp edge would cut into the solid rock to form a seal. There was a dome and a smaller cylinder within the main cylinder. Air pressure was kept at a high level to keep the mud and water out, ensuring that the men excavating the rock for the base of the central pier could work in safety. By 1850, work had progressed, and by 1856, the central pier appeared above the high tide water level.

Later, the central pier and shore-end counterparts were ready, and two enormous trusses, which had been constructed on shore, were ready to be floated into the river to be hoisted into position. On 1 September 1857, thousands of people gathered on every vantage point to see the great spectacle, it being declared a public holiday in the Three Towns and district. Absolute silence fell as the pontoons carrying the first truss were floated out into the river then placed in position between the masonry pillars. At high tide, the truss was securely fastened between the piers, causing an anxious wait until the tide fell, to leave the truss resting on piers at either end. It was delicate work when the truss began to be moved by hydraulic jack up to its final level. Brunel gave his instructions to the master of the vessel out on the river by using a specially devised system of red, white and blue flags.

By July 1858, the first truss had been hoisted into position and was safely secured in its place. The job took ten months of manoeuvring. By the time the raising of the second truss was about to proceed, Brunel was too ill to supervise the operation and this was entrusted to Robert Brereton.

On 2 May 1859, Prince Albert, the Prince Consort, performed the official opening of the bridge. Special viewing platforms were constructed, one at the Plymouth end for the royal party and another at the Saltash end for especially invited guests. The prince made his opening address from the royal carriage and then the Mayor of Saltash suitably replied. When the train was halfway

across, a gun salute was fired from high ground on the Devon side. The train then proceeded to the Cornish end of the bridge, so that the royal party could get a better view. Later, the prince walked across the bridge, showing great interest in the plans and the construction. The prince seemingly had other engagements, meanwhile the invited guests were entertained in the guildhall at Saltash. Brunel, who was suffering from exhaustion and the strain of overwork, was not present at the celebrations. He was convalescing on the continent. He was later taken across the bridge on a specially adapted railway wagon. Brunel died in the following September.

The Directors of the Cornwall Railway Company held Brunel in the highest esteem and, in honour of his achievement, dedicated the Royal Albert Bridge a memorial to him. They had his name and the date painted on either end of the bridge.

The opening of the Royal Albert Bridge marked a turning point in the history of Cornwall.

No longer was the county cut off from the rest of the country. Small towns and villages in the Tamar valley and beyond would be less isolated. The market gardeners would have faster access to up-country markets for their produce. Saltash people used the Royal Albert Bridge as a means of crossing the river after the ferries stopped running at night. The fact that they were trespassing and putting their lives at risk from trains, which ran both day and night, seemed to be neither here nor there!

Maintenance work on the bridge is carried out on an ongoing cycle over six years. In the early twentieth century, around 400 cross girders were added, and at the same time the land spans at the Saltash end were replaced, and in the late 1920s the remainder were replaced. A few years later the vertical hangers were strengthened by girders, and light latticework cross bracing was added to augment wrought iron bracing on the trusses.

When the Plymouth A.R.P. authorities sensed that war was likely they requested that the Royal Albert Bridge be painted grey. During the Second World War, rumours were rife that enemy spies were monitoring the activity on the Royal Albert Bridge, which was occasionally guarded by Home Guard units from the surrounding villages. Two level crossings were built, one at either end of the bridge, and redundant railway sleepers were placed on the bridge to afford access to military vehicles, in the event of the railway line into Cornwall being put out of use by enemy action. Despite the fact that both Plymouth and Saltash were blitzed, some sort of miracle seems to have taken place — the Royal Albert Bridge, which had certainly been a prime target for enemy bombers, remained unscathed.

Soon after turning its back on the Royal Albert Bridge the Tamar comes to the confluence with the river Lynher or St German's river.

Antony House dates from between 1710 and 1721 and was designed by Sir William Carew. The original house is mentioned in the Domesday Book. Over time the house has belonged to the Haccobbe family, then the Archdeknes and the Dawnays, followed by the Courtnenays and the Carews. In the nineteenth century the estate passed to Reginald Pole Carew, a great-grandson of Reginald Carew who reversed the surname to Carew Pole in 1926. In 1961, the house and a sizeable amount of parkland was given to the National Trust.

Even though the Tavy and the Lynher have joined the Tamar it is undoubtedly the main stream. Squeezed between Torpoint and Devonport the Tamar has its pride dented in the last miles when it loses its identity and becomes the Hamaoze, though technically it is the mouth of the river Tamar. Here it is seemingly confined by miles of admirality property.

The history of Devonport Royal Dockyard has been well documented. It all began in the seventeenth century when Edward Dummer, assistant master shipbuilder at Chatham, was asked to carry out the necessary surveys. Later his report strongly recommended Point Froward as being a suitable location. The proposal soon received government approval. Shortly afterwards, the Navy Board were ordered to put in hand all the necessary arrangements for building a single dock. In 1690, Portsmouth mason Robert Walters tendered for the work saying it could be completed within fifteen months. Around this time Dummer submitted a revised plan. He proposed a larger dry dock and a wet basin. The plan was approved and supported by King William. Seemingly the Admiralty was somewhat high-handed, as they signed a contract with the developer before any of the landowners, Sir Nicholas Morice, Mr Doidge and others, knew anything about the proposal. The dispute was settled in 1694 when the Navy eventually signed a lease renting the land at Point Froward for seven years. A few years later it had become a fully working purpose-built dockyard.

By 1700, the first houses had been built for the workers, and were the nucleus of Plymouth dock. By the mid-seventeenth century, the population had grown to half of that of Plymouth and within about fifty years the populations were equal. The dockyard continued to expand and the dock over took Plymouth. Consequently the people of the dock decided to move out from Plymouth's shadow. Representation was made in 1823 to George IV. The suggestion was looked on favourably and on New Year's Day 1824 Devonport was born. Over the centuries, Devonport Royal Dockyard has undertaken everything required to keep the Navy afloat, from wooden ships to warships and nuclear submarines.

The Royal Yacht *Britannia* was refitted at Devonport. HMS *Exeter*, noted for her part in the Battle of the River Plate and the sinking of the *Graf Spee*, was built at Devonport as was HMS *Salisbury* the first warship built at Devonport after the Second World War. HMS *Scylla*, a 250,000 tonne Leander-class frigate, was the last to be built at Devonport Royal Navy Dockyard. She was sold to the National Marine Aquarium in 2003 and in March 2004 she was sunk in Whitsand Bay and is now a popular diving reef, the first of its kind in the country.

Opposite, in the shadow of Devonport Dockyard, is Torpoint, which came into being largely as a result of dockyard expansion. Torpoint is dependent on the dockyard across the river and the ferries that sail between the town and Plymouth.

Twinned with Benodat in Brittany, Torpoint overlooks that part of the river Tamar known as the Hamoaze. From a vantage point there is always something happening on the working river — a leviathan leaving or arriving at Devonport, a flotilla of different craft, police patrol boats, yachts, pleasure steamers and the ferries all seemingly able to cope with the invasion of their river space. Mention Torpoint to anyone and the ferry immediately springs to mind. The first ferry at Torpoint is believed to date from 1790 and in 1834 a steam ferry was introduced but this proved unsuccessful. Although it became a financial liability the shareholders were obliged by contractual conditions to keep the ferry running until 1847. Fortunately, in 1835 James Rendell, a young engineer, came up with an idea for a steam and chain floating bridge. This was tried and proved to be highly successful. The same principle works on the three ferries crossing the river today, though they have been periodically 'stretched' to accommodate more vehicles. Even now pressure is always on the ferries at peak times and queues begin to build up. In 1920, the Cornwall County Council took over the ferry services.

I remember a relative telling me how a young sailor in the 1940s, based at Devonport, was courting his sister-in-law. He used to take the sailor back to Torpoint on his motor-cycle. The journey from near Launceston to Torpoint was timed in minutes, so that they could leave home at the last minute to catch the last possible ferry crossing to Devonport. Seemingly they always 'made it' as aunt Louie married uncle Albert!

The Ballast Pound, a tidal harbour, one of only two in the country, was built by the Navy Board in 1983 as part of a massive expansion of the dockyard. It covers over an acre, and its walls are 15 feet high and 13 feet thick at the base. It was originally built as a shelter for vessels transporting ballast

Looking across the Tamar to Devonport Dockyard from Torpoint. The early morning and afternoon ferries were invariably crowded with the 'Dock Yardies'.

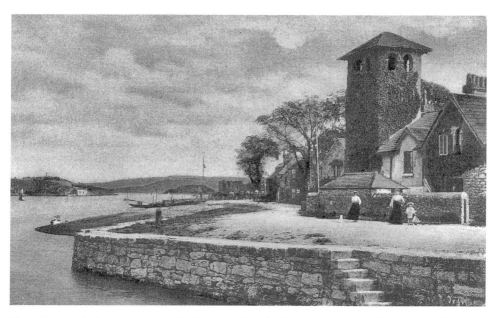

Cremyll, near the last passenger-only ferry crossing the Tamar on a regular basis. Once ferrymen rowed passengers across the treacherous waters but today a small motorised vessel is available

stone and sand needed by the sailing vessels at the time. The ballast pound was scheduled as an ancient monument in 1983 by the Department of the Environment.

There is always a naval presence in Torpoint, the two being inseparable. Since 1939, HMS *Raleigh*, the Royal Navy training establishment, where all naval rating undergo their initial training, has been only a short distance from the town centre .

In 1991, the idea was mooted to build a suspension bridge over the river at Torpoint. Some people laughingly say that it is only the chains on the Torpoint ferry that keeps Cornwall attached to Devon and if they are removed then an independent Cornwall will drift away!

Later the river makes a dog-leg turn and is jammed between Mutton Cove and Cremyll, the ferry providing a foot passenger-only service is the last of its kind on the Tamar. At one time it carried horse-drawn vehicles. The ferry, originally crossing from Devil's Point to Cremyll, was by row boat, which for passengers must have been hazardous as the currents are notoriously treacherous. It is believed to date from Saxon times but there is definite documentation of it in the earliest years of the thirteenth century when the Valletort family owned it. The rights came to Sir Piers Edgcumbe in 1511 and in 1992 they were purchased by the Mount Edgcumbe Joint Committee.

There was an anomaly attached to the ferry service. Up until 1844 it transported passengers from one point in Devon to another. This seemed to date from Saxon times. The Saxons were suspicious of the Celts and kept the mouth of the river Tamar firmly in their own control. The county border followed a small stream jammed between the villages of Kingsand and Cawsand where, to this day, there is a boundary marker attached to the wall of a small cottage in the village.

At one time, representation was made to the Earl of Mount Edgcumbe regarding updating the row-boats to steamers. He dug his heels in and refused to budge. Long discussion ensued and eventually the earl gave way. Though the steamer crossing was more expensive there was a row-boat available for the penny conscious!

During the war years, Plymothians waited in queues for their turn at the ferry to cross the river and make for the safety of the country round about to escape the ordeal of nightly bombing raids.

The Tamar passes Devil's Point on the Devon side, swirls round Drake's Island and caresses Mount Edgcumbe, which estate graces the Cornish side of the river and balances Plymouth. It occupies a unique position situated near one of the chief naval ports in the country. Built between 1547 and 1500 it has

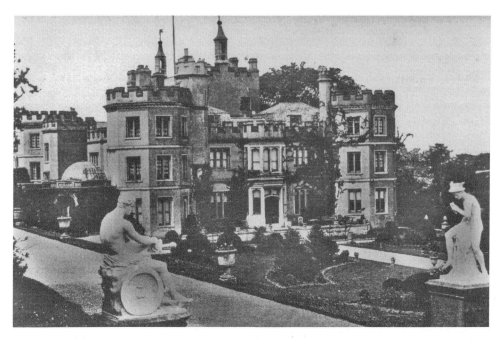

Mount Edgcumbe House overlooking Drake's Island and the vast seascape of Plymouth Sound. The Mount Edgcumbe country park offers many Plymothians from across the Tamar a welcome escape from the hustle and bustle of city life.

changed over the centuries. In 1644, immediately at the outbreak of the Civil War, Sir Piers Edgcumbe declared for the king but Plymouth, on the opposite side of the Tamar, declared for Parliament. In May that year, the house was attacked by Parliamentarian soldiers and partly burned but it held out until 1645, after which time Cromwell took delight in sequestering the land and possessions or imprisoning members of the family. In the time of King Henry VIII, Sir Piers Edgcumbe was granted a licence to enclose the land, which is now Mount Edgcumbe. An old map shows the park fenced round and an empty space where the house now stands. Lord Edgcumbe traces his family back to the Valletort family and since then Mount Edgcumbe has been passed down through the generations either by direct descent or by marriage. A painting of Mount Edgcumbe by Thomas Badeslade from 1737 shows small circular turrets at the corners of the building, which have been replaced by octagonal towers. The house was once in Devon but transferred back to Cornwall in 1844. In April 1941, during the blitz on Plymouth, Devonport Dockyard was a prime target. Incendiary bombs hit Mount Edgcumbe, fire gutted the house and most of the contents were lost. In 1944, the 5th Earl died, and the estate

Weir Quay, on the Devon bank, is a popular anchorage for countless yachts and boats on the lower reaches of the Tamar.

was inherited by Kenelm, the 6th Earl of Mount Edgcumbe. The park was used by American soldiers of the 29th Infantry Division to prepare for the D Day landings in Normandy in 1944.

After the war, the then earl took the momentous decision to approach the architect Adrian Gilbert Scott with a view to drawing up plans and eventually rebuilding the family home from the ruins. The Tudor walls and the eighteenth-century tower were saved, but the west wing was torn down. The work of restoration took from 1958 to 1964. Mount Edgcumbe house belonged to the Earl of Mount Edgcumbe until 1971 when the estate overlooking Plymouth Sound was secured in an arrangement between Plymouth City Council and Cornwall County Council.

Today, Mount Edgcumbe house is surrounded by well over eight hundred acres of land and has ten miles of coastline, all administered by the Mount Edgcumbe Joint Committee.

With its duty done, the Tamar's course is clear, but it does not go quietly and the struggle for independence is waged until it is swallowed by and sacrificed to the sea.

One thing is certain, the river Tamar will never die. It will always rise in a remote wind-swept corner of Woolley Barrows, between Bradworthy and Morwenstow and as fast as its water is discharged into the vastness of Plymouth Sound, so its water will be replenished by the rivers and streams which it embraces along its way. Perhaps one day a suitably-inscribed stone will officially mark the place of the Tamar's birth!

FURTHER READING

Booker, Frank, *Archaeology of the Tamar Valley*
Calstock History Group, *Around Calstock*
Calstock History Group, *Tamar History, (Various)*
Collacott, Cecil, *Bradworthy Past and Present*
Cornish Devon Post Launceston
Eade, Ann, *Kit Hill our Hill*
Foot, Sarah, *Following the Tamar*
Furneaux, Rob, *Tamar A Great Little River*
Isham, Ken, *Lime Kilns and Limeburners in Cornwall*
Journals of the Federation Of Old Cornwall Societies (Articles by Audrey Hosier)
Journals of The Friends of Morwellham
Kittridge, Alan, *Steamers Ferries River Tamar*
Mc Cabe, Helen, *Houses and Gardens of Cornwall*
Paige, R. T., *The Tamar Valley and its People*
Perry, Peter, *A Potted and Patchy History of Dunterton*
Rendell, Joan, *Launceston Some Pages in History*
The *Tavistock Times*
Venning, Arthur, *The Book of Launceston*
The *Western Morning News*